PIERRE HUYGHE

Untitled (Human Mask)

Mark Lewis

First published in 2021
by Afterall Books

Afterall
Central Saint Martins
University of the Arts London
Granary Building
1 Granary Square
London N1C 4AA
www.afterall.org

Afterall is a Research Centre of
University of the Arts London

Editors
Amber Husain
Mark Lewis

Copy Editor
Deirdre O'Dwyer

Project Coordinator
Camille Crichlow

Project Manager
Chloe Ting

Director
Mark Lewis

Associate Director
Charles Esche

Design
Andrew Brash

Typefaces for interior
A2/SW/HK + A2-Type

Printed and bound by
die Keure, Belgium

The One Work series is printed on FSC-
certified papers

ISBN 978-1-84638-213-0

Distributed by the MIT Press,
Cambridge, Massachusetts and London
www.mitpress.mit.edu

An Afterall Book
Distributed by The MIT Press

Each book in the *One Work* series presents a single work of art considered in detail by a single author. The focus of the series is on contemporary art and its aim is to provoke debate about significant moments in art's recent development.

Over the course of more than one hundred books, important works will be presented in a meticulous and generous manner by writers who believe passionately in the originality and significance of the works about which they have chosen to write. Each book contains a comprehensive and detailed formal description of the work, followed by a critical mapping of the aesthetic and cultural context in which it was made and that it has gone on to shape. The changing presentation and reception of the work throughout its existence is also discussed, and each writer stakes a claim on the influence 'their' work has on the making and understanding of other works of art.

The books insist that a single contemporary work of art (in all of its different manifestations), through a unique and radical aesthetic articulation or invention, can affect our understanding of art in general. More than that, these books suggest that a single work of art can literally transform, however modestly, the way we look at and understand the world. In this sense the *One Work* series, while by no means exhaustive, will eventually become a veritable library of works of art that have made a difference.

Pierre Huyghe
Untitled
(Human Mask)

Mark Lewis

.

Contents

The tavern was abandoned after the 3/11 earthquake and tsunami. The monkeys still belong to the owner. The current state of the tavern and the monkeys was documented in a 2014 movie by artist Pierre Huyghe.
– 'Kayabukiya Tavern', Wikipedia[1]

Tell me things I won't mind forgetting, she said. Make it useless stuff or skip it.
– Amy Hempel[2]

What's it Like to be Almost Like Something Else?

It's a film, about nineteen minutes long, in colour and with sound. It loops. It opens with views of a deserted, largely destroyed town. There are abandoned buildings, some barely standing, others still recognisable from what they used to offer: food, drink, assorted trinkets, probably furniture and a do-it-yourself shop. But it's hard to make out a lot of detail. There are Japanese street signs. Grass has grown through pavement, probably for a year or two already. Piles of trash in black garbage bags are gathered by the side of the road next to abandoned kitchen machines, fridges, air conditioning units. A slight breeze drives a flutter through the plastic barrier tape, now loose and forever purposeless.

Into this post-apocalyptic world drives the camera drone that shares these images with us. It's shooting from hip level, I surmise – low flying, maximising the intimacy of encounters, but maintaining indifference in the way only something fully automatic can. The camera drone is on a mission, growing restless and occasionally ramping through compositions. This kind of movement, full of plotted curves, is technically precise, the fulfilment of a powerful dream. Human disappearance seems recent, no more than a few years back, but the emptiness feels thick already. The camera drone moves through a series of ruin tableaux, edited together to suggest a final destination. Suddenly we arrive. The camera is inside a building. No longer flying, its grammar shifts: the detached automation of the exterior sequence gives way to an almost tender intimacy. It feels like the camera has been there before and knows where the good seats are.

The camera tilts down and reveals a little girl. There is something strange about her, as if not quite real. After a certain amount of camera coyness, we realise that the girl is in fact a dressed-up monkey, with white mask, wig and dress. Why? It's altogether uncanny.

The camera is now going to let us watch her do monkey things for the next seventeen, eighteen minutes. Along the way we'll meet a few friends, albeit briefly. There's a cat, a cockroach and some larvae, probably cockroach offspring. And we'll learn a bit about the space, a restaurant with a once-busy kitchen, now looking as though abandoned mid-sentence. It will start to rain; some water will leak in and drip conspicuously. The monkey will (appear to) ponder, be restless, be curious, be cautious. Dressed in her frock, white mask on, she has one or two activities particularly prepped: she retrieves hot towels, puts them on tables and returns with what appears to be liquor. She even does that spinning, dizzying, falling down party trick that children love so much.

Untitled

The monkey of sentiment relies above all on the catalogue. It should be noted, however, that the picture's title never tells its subject.
- Charles Baudelaire[3]

It might appear on the window of the gallery, attached to a wall inside, printed in an exhibition catalogue, or on the lips of a gallery attendant or auctioneer. And it circulates – in magazines and books and conversations – always on behalf of a work. A title is usually composed at the end, but appears like an epigraph. Therefore it is an extra, an embellishment and a precursor, announcing what to expect. A title performs the work and performs on its behalf. A title is, in effect, the work's own avant-garde.

Until the eighteenth century, artworks almost never had titles. They generally didn't travel and were typically identified by what they depicted and where they lived most of the time. For instance, 'Raphael's Madonna and Child at the National Gallery' was all you needed to know. Fancy titles, metaphors, allegories, nonsense, negation, 'untitled' – that all came later. Ruth Yeazell argues that with the emergence of the modern market, auction houses and commercial travelling exhibitions, the title becomes an essential track-and-trace device.[4] In other words the title becomes a stand-in for the work, trying to become identical with it. Marcel Duchamp referred to the title as an invisible colour, and John Welchman, whose book takes its title directly from Duchamp's formulation, describes three ways in which titles can work:

First, the continuation of broadly denotative titles, where the words are presumed to stand in direct and untroubled relation to that which is represented. Second, the set of titles that can be said to provoke connotative, allusive, or even, in Dada and Surrealism, absurd and non-consequential references to an image. And third, the conclusively modernist practice of advertising the absence of a title through the description 'Untitled' or through numbering or other systematic, non-referential designations.[5]

It's a curious thing, a title. As an artist, I'm often disappointed with my own, thinking they provide too much information or perhaps not enough. *Untitled (Human Mask)* (2014), by Pierre Huyghe, poises elegantly; it is finely balanced on a tightrope between the too much and the not enough, drawing attention to the divided and contradictory performance of titles. The menu is in two parts and the ingredients contradict. 'Untitled' is a 'recognised' title – currently very popular, though probably not as popular as in the 1950s and 60s in New York. 'Untitled' was born of artists' resistance to the very idea of titling, and their demand that works be encountered and absorbed without textual entrée. Many such artists took their cue from Picasso, who usually refused to title his works, declaring that the works had to 'speak' for themselves. Yet, 'Untitled' does entitle a work of art, and its ubiquity, especially among the high modernist works of the second half of the twentieth century, has effectively defanged it. It feels mannered now, denuded of its power of aesthetic disruption. *Untitled (Human Mask)* draws our attention to 'Untitled' as a title by recalling its relatively short history of disruptive agency, deliberately antagonistic to the power of titles that specify something in particular. The 'Untitled' title, coming first, not tucked shyly between parentheses, wants to draw attention to the overbearing signifying weight of a title and put it *sous rature*. The parenthetical title 'Human Mask' clearly undoes that ambition (parentheses qualify, but they can't nullify). So 'Untitled', with the hard adjacency of the parenthetical title, strangely obtains some power as entitled; it cancels out the words that draw our attention to something specific. It openly embraces (and names) the confusion and contradiction that plagues all titles, turning the title here into a kind of provocative nonsense. Huyghe has form in this regard; the name of his extraordinary piece first exhibited in 2012 at dOCUMENTA (13) in Kassel was provocatively titled *Untilled*.

Untitled (Human Mask) is not only provocative nonsense but also sluggishly schizophrenic. To be untitled, as in without title but parenthetically titled, is a parergonal envelope wrapped tightly around a critique of titling – of how titles struggle to mean and the 'damage' they can do. This combination, an untitled title with a titled title in parenthesis, is far from rare. Examples include Jean-Michel Basquiat's *Untitled (Skull)* (1981) and *Felix Gonzales-Torres, Untitled (Girlfriend in a Coma)* (1990). There are thousands of these. The contents in parentheses are sometimes added by galleries, auction houses or dealers, generally with a view to selling the works. But *Untitled (Human Mask)* is 'deliberate'. It's there from the beginning, and for this viewer at least, measuring the truth value and confusion of the work's title while watching the film has been a consistent handshake. I've never read Kierkegaard, but there's a line I like that gets quoted a lot. With regard to faith, Kierkegaard apparently declared that the ambition is to 'arrive at immediacy after reflection'.[6] I think that's how the title of *Untitled (Human Mask)* works.

Of course, the parenthetical title 'Human Mask' draws our attention to the mask worn by the monkey in the film, suggesting that it is a simulacrum – a representation or image – of a human face. This question of something representing, of 'being like', something else is complex and weighs heavily on this film and its depiction of resemblances and differences. But we should immediately note that the mask in question is really nothing like a human face. This type of mask is typically worn by humans to look theatrically less like themselves, less specific. In Gaston Leroux's serial novel *The Phantom of the Opera* (1909–10), the phantom declares that in order to hide the particularity of his hideously deformed face he has 'created a mask that makes [him] look like anyone else'.[7] A mask can certainly indicate a 'type' or a parody; either way, what's interesting is how the wearer or bearer of the (human) mask could be said to be deliberately 'untitled' by it; as if, in Huyghe's film, the mask were a stand-in for 'Untitled' in the title. There is no human in the film *Untitled (Human Mask)*, or at least not in frame, but there is a mask.

I began this discussion of the title with an epigraph taken from Baudelaire's critical writings on the 1846 salon. I confess I chose it simply because of the delicious coincidence of 'monkey' and 'title' appearing in consecutive sentences. 'Les singes du sentiment' are despised by Baudelaire as weak painters, foolishly relying on text, such as titles, to do the work their

paintings should be doing. The title is not earned, so it does not belong. On sifting through Baudelaire, Derrida, Welchman, Yeazell and others, it seems the underlying consensus is that titles are necessary, but still should be avoided. As I write, titles are in the news: there have been demands to change the tendentious, sometimes overtly racist ones attached to older works. These are the nomenclature wars. Some have warned against judging the past by the standards of today. But they have obviously forgotten that the past is contingent, and commemoration is either sustained by consent or imposed. Contested titles are often imposed after the fact of the contested thing they name, by owners, art critics and even politicians. They seldom have existential claims on the works. David Lowenthal put it well: 'To know is to care, to care is to use, to use is to transform the past';[8] and Ann Patchett, perhaps better still: 'Walking backward is an excellent means of remembering how little you know.'[9]

Damnatio memoriae – the erasure and transformation of memory when power and/or knowledge shifts – has, until very recently, been an essential part of commemoration and memorialisation, almost from the very beginning of such things; and the holding onto titles, like the holding onto offensive monuments, is paradoxically a relatively modern condition. 'The Roman damnatio memoriae worked like Piranesi's: to dishonour memory, not to destroy it.'[10] In the exhibition 'Black Models: From Géricault to Matisse' at the Musée d'Orsay, Paris in 2019, paintings such as *Portrait of a Negress* (1800) by Marie-Guillemine Benoist were renamed – in that case, as *Portrait of Madeleine*. Édouard Manet's *Olympia* (1863) was renamed *Laure*, after the model who posed as the maid in his painting. Both re-namings feel somehow right, as the works continue to connect with contemporary life. Some memories deserve and need to be dishonoured.

In Huyghe's film, the parenthetical title, like the actual mask itself, draws keenly nuanced attention today. As I have walked to my studio to work on this text, over the spring of 2021, most everyone I've seen has been wearing a mask, often with distinctive designs. As I write, I have just seen an image online of a protest against vaccines and Covid-19 rules in San Marino (fig. 1). One of the most puzzling phenomena of the last year has been a certain variety of protest: the demonstrations against lockdown, vaccines, almost anything to do with pandemic-related rules and restrictions. The look of these protests – uniforms, signs, face coverings and slogans – has

often been confusing. Ask yourself: How does the mask of a young woman protesting against mask-wearing make any sense? How does her mask, for instance – sort of Venetian carnival meets Anonymous – critique mask mandates? The San Marino woman's mask is strikingly similar to the one worn by the monkey in Huyghe's film. Five years ago, for me at least, these signifiers did not connect. Will they still connect five years from now? Even for most of the duration of the pandemic, until a friend pointed it out to me, I hadn't noticed the connection between *Untitled (Human Mask)* and the mask on my own face.

Throughout this text, I have resisted using shorthand for the title *Untitled (Human Mask)*; by repeating it in full, its deliberate contradictions are emphasised, its provocative nonsense. And, as this is a housekeeping segue, I should say I have also resisted giving a specific gender to the monkey in the film. The monkey's costume suggests she is female, but the tradition of Noh masks, wherein men wear masks to play women, would suggest that underneath he is male. Nameless, she remains unknowable in this sense, and I have rotated his gender throughout, sometimes in a single sentence. Same with the cat who makes a brief entrance, *comme il faut*, while I simply punted on this gender question with the insects.

Disposing of Leftovers

In July of 2020, during the pandemic, the artists who own the building where my London studio had been located for eighteen years decided to evict me with just one month's notice. So while writing this text, I have also been clearing out my studio. I didn't think it would take long, but the process has been endless. I threw a lot of things away. Why, I wonder, did I keep six copies of a catalogue containing a single small reproduction of one of my works, so small it was almost impossible to find? But there they were, the six of them, proudly upright and adjoining, shouldering dust, yes, but otherwise in good condition. For whom was this imagined posterity? Most likely it would have become a problem for my children, one more thing to get rid of after my end. I threw five away. Multiple copies of other forgotten accomplishments were also summarily disposed of.

I found one catalogue that pulled me temporarily out of this burdened reverie. It was for a 1999 group exhibition, 'Cinéma Cinéma: Contemporary Art and the Cinematic Experience', at the Stedelijk Van Abbemuseum in

Eindhoven. I had two films in this exhibition, as did Pierre Huyghe. In fact, it was the first time I had ever seen Pierre's work and the first time we met. Career-wise, Pierre and I came of age, so to speak, at the same time. It would be fair to say that he has been more successful than me, though perhaps it wasn't always clear that this would be the case. I think we spoke briefly at the opening dinner. I was curious about his work. It seemed low-tech but serious. Mine was high-tech, trying to be funny. What *is* funny is that twenty plus years later we seem to have swapped things around: I'm generally pretty low-tech, whereas works like Huyghe's *Untitled (Human Mask)* seem polished and 'professional'. More so than, say, his *Remake* (1995), which, according to the catalogue I had just found, was exhibited in Eindhoven back then.

I tried to think if there were other group exhibitions we had participated in together. But I couldn't remember any, which is strange given the proliferation in the late 1990s and early 2000s of group shows on the theme of art and the moving image. That thematic may have been necessary back then, when museums and curators, and artists too, wanted to define moving-image art as different from artists' films, making the former collectable as art rather than film. Maybe there were other such group exhibitions Pierre and I were both part of, documented in publications I'd already thrown away. Today that theme seems less useful, the moving image being an established art form. I remember, very vaguely, a conversation with Pierre back then where he expressed an indifference to the 'moving image' thematic and a desire not to be known as a moving-image artist. Perhaps he simply exited that particular circuit early.

Eventually, a huge amount of books, catalogues and other printed matter, once destined for a now cancelled posterity, filled more than a hundred extra-large garbage bags, which were then placed in large 'recycling' bins, the contents of which, more likely than not, were destined for equatorial Africa, where they would be burned outside by small children without masks or protection, earning just a few cents a day. Sometimes a long sentence is needed just to bring everything together. *Morituri te salutant.*

Disposing of leftovers; readying for final departure. It was inevitable, I suppose, that, like all movers and packers before me, I would think about the things I had done and not done during my almost eighteen years at that studio. Not doing something can be significant – sometimes more significant than a great success. There are lots of things I have almost done but haven't, like

writing a book, sailing around the Cape of Good Hope or getting a PhD. And then, there are all the films I thought I might make but didn't. Some of these films still exist in minimal form, barely legible lists of things to think about, scattered across studio walls and desks, some with instructions: *Camera rises rapidly, vertiginously to the cupola, pauses for some moments, then descends vertiginously over the head of a supplicant.* 'Vertiginously'? Didn't I read somewhere that adverbs rob verbs of their authority? What I do know is that this fantasy film of mine, (not) made inside Francesco Borromini's Chapel of Sant'Ivo alla Sapienza in Rome, is perhaps the biggest, most important, of all my failed films. It's a project that has dragged other people in its wake, more than one of whom worked for a year on detailed preparations. And still it remains ... well, vertiginous. The making of this film has travelled with me and I continue to find opportunities to talk and write about it. I often wonder, sometimes aloud in front of others, how it is that my desire to make that film has changed the way I think about all film. There is a 'before' and an 'after' not making it. Unfinished projects, planned but not executed, perpetually taunt. It's as if the past gets reimagined as a growing accumulation of *créatifs de l'escalier*.

One of my more recently unfinished projects, at least until now, has been this very book. At least five years ago I promised many people (colleagues, Pierre himself, the MIT Press) that I was just about to start working on it – that I was just days, minutes away from putting pen to paper. And each week, each month, for several years after, I didn't start. I'm wondering now if there is something significant to this failure? And I think I'm probably on to something here, because I do recall thinking about failure *in genere* when I first saw *Untitled (Human Mask)*, on a cold, wet autumn morning in London, probably seven ago. Watching the film through several cycles, much as I knew that I really loved it, it also irritatingly reminded me of the difficulty of ... well, doing difficult things, as if *Untitled (Human Mask)* were the realisation of an unmade film that could have been mine.

Why would I want Huyghe's film to be mine, I wonder? Rivalry, certainly: wishing that I had made it, had thought of it, planned it, persuaded others to work on it; that I had engineered the obviously difficult film shoot with a monkey. But more specifically, I think it feels like the kind of film I might once have made: a very difficult location; a complicated *mise en scène*; a startling discovery; and perhaps most of all, a depiction of something

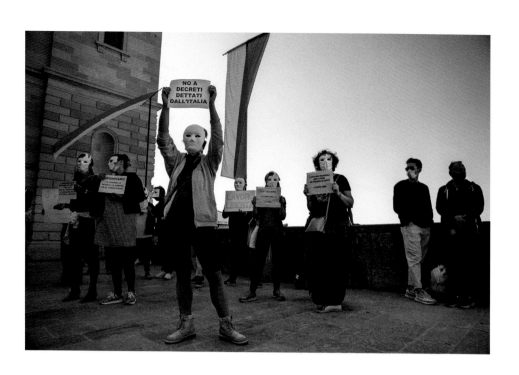

1. Masked protestors in San Marino, 2021.
Photo: Nadia Shira Cohen

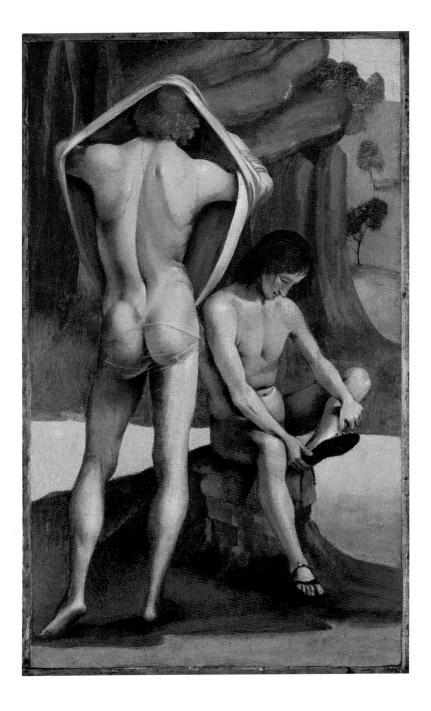

2. Luca Signorelli, *Figures in a Landscape:*
Two Nude Youths, c.1490, oil on canvas,
67.9 × 16.4cm

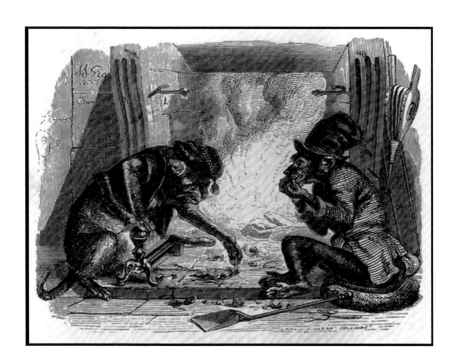

3. J.J. Grandville, *The Monkey and the Cat*,
engraving from the 1855 edition of Jean de
La Fontaine's *Fables*

4. Congo, *30th Painting Session*
11 December, 1957

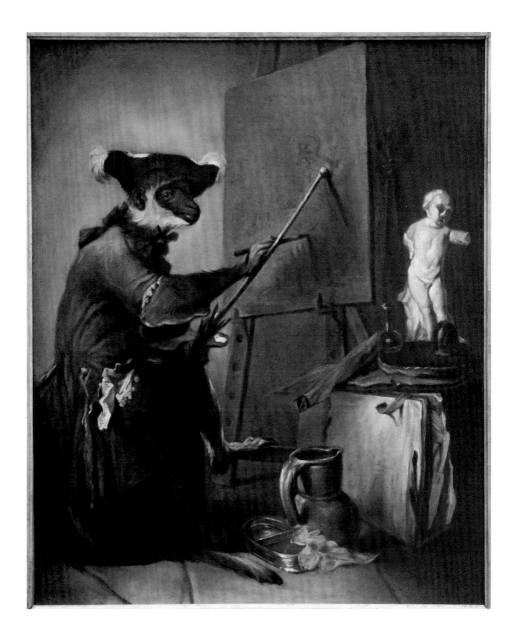

5. Jean-Baptiste-Siméon Chardin, *Le Singe peintre*, 1740, oil on canvas, 73 × 59.5cm

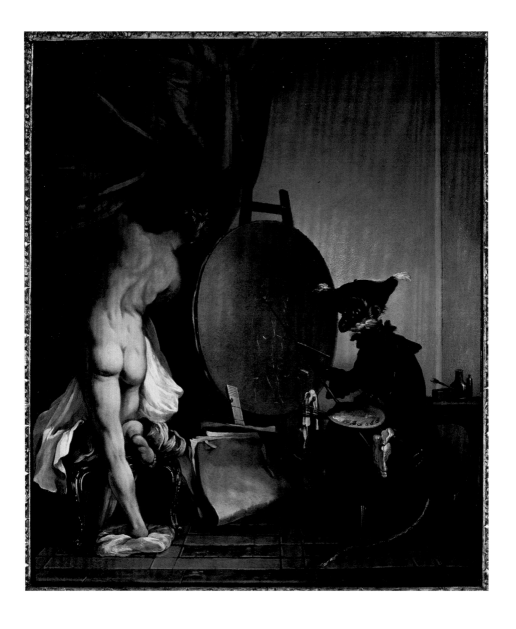

6. Jean-Baptiste Deshays, *Le Singe peintre*,
c.1745, oil on canvas. Photo © RMN-Grand
Palais/Gérard Blot

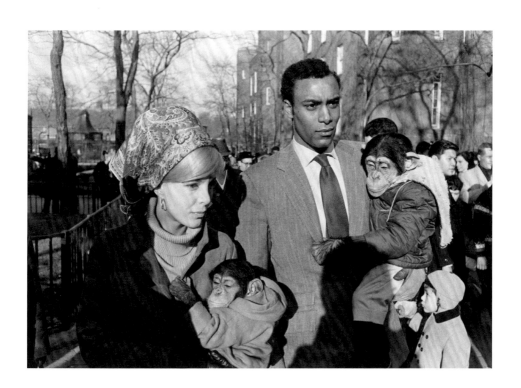

7. Gary Winogrand, *Central Park Zoo,*
New York City, 1967, gelatin silver print,
23 × 34 cm. © 1984 The Estate of Garry
Winogrand. Courtesy Fraenkel Gallery,
San Francisco

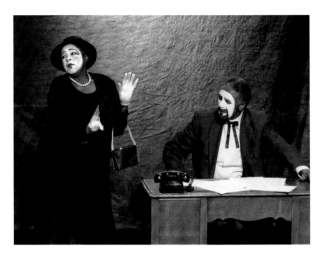

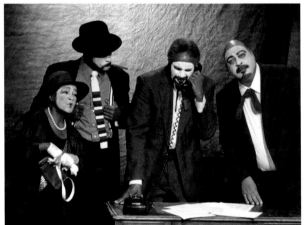

8. Douglas Turner Ward's 1965 play *Day of Absence*, performed by the Negro Ensemble Company, 4-11 December 2016 at Theatre 80 St Marks, New York, directed by Arthur French. Pictured in middle image, from left: Cecilia Antoinette, Jay Ward, Charles Weldon, Chauncey DeLeon Gilbert. Photos by Jonathan Slaff

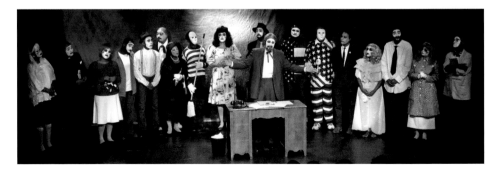

interesting without a real end or conclusion, existing rather as a series of questions. I saw *Untitled (Human Mask)* for the first time at the moment I realised that my Borromini film was not going to get made. Was it, I wonder, a loss of agency, of verve, of money even? Why did *I* give up on the film while here was Huyghe managing something equally challenging, impossible in the same way as mine, but made nonetheless. 'In every work of genius', says Ralph Waldo Emerson, 'we recognise our own rejected thoughts; they come back to us with a certain alienated majesty.'[11] We all live with this imaginary dimension of possibility when other lives seem possible. 'Our self-portraits', writes the historian Joshua Rothman, 'use a lot of negative space.'[12]

Prologue and Disaster *Mise en Scène*

'You could see these little figures scurrying, and the explosion going off, and when the smoke cleared there was just rubble and charred stuff', a former CIA officer who was based in Afghanistan after September 11th says of one attack. (He watched the carnage on a small monitor in the field.) Human beings running for cover are such a common sight that they have inspired a slang term: 'squirters'.
– Jane Mayer[13]

When the film begins, the street-level drone sequence tracing the destroyed urban landscape lasts for one minute and five seconds. The destruction seems relatively recent. But the scene's contextual resonance outbids its brevity: everything that follows will be tempered by this performance's signification. These are drone shots of a town devastated by an infamous one-two-three punch: Tōhoku earthquake and tsunami, Fukushima Daiichi nuclear plant meltdown. This specific context is documented in all the literature surrounding Huyghe's film; yet despite this, it also feels generic, a metaphor for these troubled times. What we are witnessing could easily be the end of the Capitalocene, or the emergence of the environmental un-canny as the 'last exit human'. Humanity's final, permanent peripeteia. As I write I have just listened to an interview with Noam Chomsky. Ninety-three years old with age defying intellect, he pointed out that when Jim Mattis, US Defence Secretary from 2017–19, outlined the US military strategic posture, it was essentially in preparation for simultaneous nuclear war with China

and Russia. Pause for a second and take that in carefully: the United States has effectively been preparing for the total and complete annihilation of life on this planet. Not to *stop* it, but if necessary to *participate in* it.

The very obvious drone shots drill with machine precision through a ruined and abandoned urban landscape, still bearing remnants of what seems to have been quite recently 'modern'. We see restaurants and offices branded with their abandoned identities; many buildings half destroyed; a long street that looks as if it may have been a very important one; and later, things arranged, laid out as if they were waiting for humans to return. Everything feels orphaned and ossifying in that state. It's uncomfortable; the depiction is grim.

At least two of the drone shots ramp, and this, to me, is strange. Ramping – changing frame rates mid-shot – is a familiar technique. *The Matrix* (1999) was apparently the first commercial film to use ramping. Like drone shots, ramping is now ubiquitous. It's a small machinic rebellion by the camera, gaming its technical otherness: *Your unassisted eye can't do it, but I can.* But like most over-employed things, it has become a kind of tick in a lot of films, music videos and TV. I confess I can't unthread any interesting explanation for the ramping's inclusion in Huyghe's prologue. For the longest time I tried. But ramping effects are jarring, noticeable. They are puzzling, robotic – obviously. They even title the sequence, give it an air of purpose. But that purpose remains open-ended. Good art, Jasper Johns once said, is an accomplishment in ambiguity. It is interesting that 'drone' also names a particular musical effect, a repetition that is more sound than melody. Drone music is often described as the intonation of ineffability. It aestheticises doom, says the musicologist Joanna Demers, 'opening a door onto once and future catastrophes, those that are immanent and those that, once believed to be imminent, are now detours in a past that turned out otherwise'.[14] Drone music aims to defy meaning, to 'flout' interpretation.

The writer Alex Quicho, in her book on drones, reminds us that 'though we're most inclined to think of it as an eye-in-the-sky, the drone is usually heard before it is seen. To get why it haunts our collective psyche, we first have to listen to its dread-noise.'[15] The first radio-controlled aircraft was developed in 1935 by the British military and called the DH 82B Queen Bee; her many offspring are the drones that fly today. Drones are male bees without stingers – unloved, disposable and eventually killed by other bees. The first military drones were used for target practice; only much later did they

start looking for targets themselves. Today's electric drones sound distinctive and much quieter than their diesel-engine ancestors. In the opening shot of *Untitled (Human Mask)*, we have the tell-tale buzz of an electric drone, a well-recognised contemporary signature of the shots' technical origin. After the first shot, the drone sound drops away, but other repetitious sounds come in and out: a woman's voice in broadcast mode, repeating something official, important – perhaps the last thing anyone will ever hear.

The philosopher Grégoire Chamayou has described the history of the drone as that of an eye turned into a weapon, one that makes it virtually impossible to die as one kills. Today drones, piloted by US contractors based in Las Vegas, are re-staging, in the skies over Pakistan, Afghanistan, Somalia, Sudan, Syria, Palestine and Yemen, the massive asymmetrical slaughtering of American indigenous peoples by sixteenth- and seventeenth-century English, Portuguese and Spanish guns. Typically drones adopt the view of the gods, but in *Untitled (Human Mask)* the drone is at street-level, perhaps wheeled as well as winged.

The drone sequence feels like a prologue. *Prologue* comes from the Greek *prologos*, literally 'speaking before', enabling the revelation of things and ideas that should be recognised and understood before the rest of the story unfolds. Here it figures something substantial: the apocalypse. This is the film's backstory. It's either recognisable and looks bad, or it just looks very bad even if you don't recognise it. The apocalypse is a revelation or disclosure of great knowledge; it often glues itself to the end of the world, but not necessarily. In Christianity, it is 'a vision of heavenly secrets that can make sense of earthly realities'.[16] The question of what comes after the apocalypse, what the 'after' might feel and look like, is a question that has consumed cultures and faiths, particularly Christianity, which has produced extraordinarily ambivalent works of art, full of tempest and temptation, death and sex, and punishment for everything. Now we have lost faith. The End was once a story about something specific to come, whereas now it is everywhere, all the time.

Untitled (Human Mask) confirms this contemporary condition of immanence. Its relentless documentation of a creature exploring what was once our world confirms our very worst fears that the end is not a story, but the reality of who we are. And because of that reality we will never bear direct witness to the monkey's disinterestedness. We are absent and thereby irrelevant. It's these thoughts that have me circling around and around the

film, making me dizzy with references and a multiplicity of leads. It's a work that wants you to imagine, to think around and across, to follow leads as the film settles into its very casual routine. Though the end is everywhere in *Untitled (Human Mask)*, it does not stop there.

The Abduction of Gesture

We need to embrace the vile along with the valiant, the evil with the eminent, the sordid and sad as well as the splendid. For the whole of the past is our legacy.
– David Lowenthal[17]

Thinking about the apocalypse, drones and the ineffable, I was interrupted by the memory of a visit to Orvieto, in Italy. I had gone to the ancient hilltop city to look at Luca Signorelli's depictions of the apocalypse and the last judgement in the Duomo's San Brizio chapel. After suffering one terrible disaster after another, at the turn of the fifteenth-century Orvieto was on edge, tightly bound by a torque of collective anxiety. For five years Signorelli worked day and night on his images of the end; for the town's citizens the eschatology would have felt very close, an emerging documentary of their own end-of-the-world anxiety.

I had gone to Orvieto to research a possible film to be 'set' in the chapel. I had only really discovered Signorelli within the last year, in the exhibition 'The Renaissance Nude' (2019) at the Royal Academy of Arts, London. A good friend of mine and I were completely stunned by a small painting by Signorelli, *Figures in a Landscape: Two Nude Youths* (c.1490) (fig.2). I made a film inspired by this discovery and I wanted to tell everyone about it – the painting, the discovery, the new film. But I kept forgetting Signorelli's name. Over and over again: it became pathological. Losing myself in the Google slipstream (and with a nudge from a good friend), I discovered that Freud had more or less invented his idea of the parapraxis after visiting the chapel to see the famous work and misplacing Signorelli's name. Freud observed that while accidents happen, mistakes are *made*. The frescos are shocking and full of psychoanalytic effect. It's somehow pleasing to know that the 'slip of the tongue' was given its proper psychoanalytic form in connection with a mistake while looking at a work of art. When I stood in the chapel – the only person there, straining

to take in all the terrifying magnificence surrounding me, up and around – I fantasised a drone flying through the chapel with elegant swoops, collecting intimate compositions for my own film, to reproduce, in the third and fourth dimensions, the impression Signorelli's dramatic forms make. What about the sound of this drone? Should I hear it? An authorial flourish?

It was then that I realised the deep connection between Huyghe's *Untitled (Human Mask)* and Signorelli's frescos in Orvieto. They complement each other across five hundred years, mapping the transformation of 'the end', the apocalypse, from imminent to immanence. We know Signorelli was not depicting an absolute end without a sacred after. Christianity conveniently smuggled in a time for after the end, while obviously limiting those who could join. In *Untitled (Human Mask)*, the end is rendered in the present, in everything all at once. Its unthinkability, its existence outside of narrative, is what is so terrifying. The drone fantasy led me to Orvieto, but Signorelli's and Huyghe's depictions of 'the end', their part in a long tradition of depicting the undepictable, this is what has kept me looking.

Inside

And then we are inside. The conceptual leap from the exterior to the interior of a restaurant/bar, *in media res*, is seamless. A montage effect that Sergei Eisenstein, building on the work of Lev Kuleshov, made influential. Chaplin, Hitchcock, Welles and Coppola all learned their montage tricks from watching Eisenstein's *Battleship Potemkin* (1926). But the camerawork and montage inside Huyghe's restaurant are different from those in that film. From now on, *Untitled (Human Mask)* will be all tidy compositions, artful in a recognisable way. Focus is pulled carefully, revealing familiar, punctuated handheld compositions. It has all the slowed-down, syntagmatic rhythm that typically follows something disturbing and obviously dramatic. Like a pause. In other words, it is *cinematic*. And yes, something dramatic *has* happened outside and continues to extend its influence inside. Syntactically we might expect a return to the rawness of the exterior terror before the movie ends, perhaps revealing 'the story behind'. But this doesn't happen. The exterior robotic camera and its mobility device presented a compelling backstory, but with the exception of three brief shots of the rain falling on the outside of the restaurant building towards the very end of the film, inside is where the rest will take place. Always, however, in the conceptual and figurative shadow

of the exterior apocalypse. The brief late shots of the restaurant's exterior herald a return to the disaster *mise en scène*, even if they seem more pastoral and moody than threatening. The exterior shots have the feel of a real 'movie'. After a shot of the monkey looking at water dripping inside, there is a cut to outside, to rain falling on a bush and the restaurant's roof. There is no monkey in the three shots in this interregnum. Nor does the shooting share any of the machinic grammar of the prologue.

Can we even think of the interior scene as a narrative already in progress, in the *middle* when we join it? The living participants that we are introduced to in the film are, in order of appearance: a monkey, a cat, some larvae and a cockroach. Does the idea of a plot occur to them, and if not, should it occur to us? You could argue, of course, given what we saw at the beginning, that these creatures are somehow in the middle of the biggest narrative plot since Genesis. But presumably the magnitude of this escapes each of them. Or they just don't give a shit. For the monkey, nothing seems to discommode - she just streels around and does her thing. With the cat, not much bother there either. I read somewhere that monkeys, like cats, sometimes play easy to get, hoping to get something in return. As for the cockroach and larvae, a motley parade, who can say?

Humans are always in the middle of things, a temporal point that has no significance whatsoever. We are quite simply in the middle of our extinction, a point between an origin and an end. Frank Kermode said that if we are always expecting the apocalypse, we make our middle time special. In other words, our lives can have meaning if we glimpse the end - imagine it, factor it in.[18] All of us are living in the shadow of the end; it draws closer and closer, eventually becoming overwhelming, an accelerant. Philip Larkin put it succinctly in his last great poem, 'Aubade' (1980), where (killing himself with drink) he reflects with a mix of terror and intense curiosity on his own impending end: 'Most things may never happen: this one will.'[19] An 'aubade' is a poem or piece of music appropriate for daybreak, a love song, for instance, to complement lovers parting at dawn, just before the morning hardens and becomes full of ordinary things. Larkin's is a beautiful poem, full of melancholy and wonder, and it speaks to the vital fear of death that can consume anyone facing their end. Based on the average extinction span of an evolved mammal - about half a million years, apparently - the human race is now in its early teen years.[20] This might go a long way towards ex-

plaining the manic recklessness of the last couple of thousand years. It also could present us with a serious warning for the older teenage years to come. Larkin again:

> The sure extinction that we travel to
> And shall be lost always. Not to be here,
> Not to be anywhere,
> And soon; nothing more terrible, nothing more true.[21]

The interior filming starts all coy, with fifty seconds of shots that tease and mislead, about a girl or very young woman in the restaurant. Perhaps a 'left behind' or the last person alive. The camera and the careful editing are playing with us, creating mystery, waiting to surprise us. We expect the curious figure soon to disappear into recognition. Before that can happen, we notice, or are startled by, the white mask that covers the figure's face. Juxtaposed with all the signifiers of Japan in the film, you might assume this to be a Noh mask. Confronted also with the careful lighting and everything else besides, you might think you are watching a performance of juvenescence. But it's all an illusion. Soon we see hairy, skinny little arms attached to prehensile hands. It feels suddenly uncanny, this little girl who is also an animal. Monkeys are usually represented as childlike. When I was a child, I loved *Curious George*, and I read all the stories in turn to my children. When I look at those books now, though, I'm troubled by things I never noticed before: that George is uncivilised and childlike despite his age; that despite saving the day hundreds of times he rarely earns the respect of the bland white males that define his world. Most of all, even though George seems to understand everything, he is deprived of language, of the symbolic. As June Cummings notes, George's escapades are seen as 'rascality', the name given to the behaviour of the enslaved when things got broken or mistreated.[22] The monkey becomes a stand-in or metaphor for all discriminated against and colonised peoples treated as children by white citizens and settlers.

There is at least one cultural monkey that *does* have language: the Signifying Monkey of African folklore, a monkey in a tree who uses language to trick a predatory lion lying in wait. Henry Louis Gates, Jr describes how this powerfully clever character lived on in the oral traditions of the enslaved in North America who, through irony and tricksterism, subverted the op-

pressive language of their enslavers.[23] Gates describes how a radical tradition of African American literature drew some of its authority and strength from the use of the Signifying Monkey in oral traditions. While I learned about this only very recently, and can detect no clear or obvious reference to it in *Untitled (Human Mask)*, I can no longer look at any representation of monkeys without pondering these things.

If you accept what you are watching is a film and not 'things themselves', then anything your eye gets glued to, that strikes a thought in you, or has a likeness with something you have seen before, is a prop. In *Untitled (Human Mask)*, the country of Japan is a prop, represented in turn by a series of smaller props – placed significantly, brought to close attention. For instance, a *maneki-neko* (beckoning cat) sits on a shelf next to a fax machine, its one arm moving back and forth. There is a series of tightly framed, extreme close-ups of this possibly porcelain (more likely plastic) feline effigy. They follow, consecutively, a medium shot of the live cat, a medium shot of the monkey looking down and a close-up of the monkey's swinging leg. Here, two different kinds of things are presented as like each other: a swinging leg and a swinging arm; a real cat and a cat made from plastic (possibly porcelain). Traditionally, a *maneki-neko* brings good luck: the right paw waves good fortune to its owners; the left greets new customers.

The *maneki-neko* and the mask are in a geomantic orbit of special props. There is a cut back to a wide shot of the cat in the middle ground with the monkey, his mask and her swinging leg behind. Just in case we failed to bring it all together. The prop is a *deus ex machina* – therefore it's a cheat – but it confuses more than it resolves. Our attention is drawn to things that oversignify, that have too much cultural significance. Props have less to do with what they are in themselves than the desire to make use of them. Here, they seem to raise more questions than they answer.

Another prop is the monkey's dress. Thorstein Veblen, the late nineteenth-/early twentieth-century radical economist and cultural theorist, argued that dresses and skirts 'incapacitate[d] [women] for all useful exertion'.[24] A dress declared that the wearer could either afford to wear something extravagant that had little utility for work, or it enforced the idea the wearer of such an inconvenience was incapable of serious activity, thus rendering them second-class, dependent. Why is this monkey wearing a dress? What kind of extravagance is it advertising, or what kind of dependence is it un-

derlining? The dress hides the monkey's sex, but at the same time reminds us that there is something underneath. The dress sexualises her, not for what it shows, but for what it hides. A dress is a very interesting prop indeed. And is she wearing a diaper? Monkeys in captivity are apparently notorious shit throwers. Their aim is remarkably accurate and they hit their human spectators more often than not. In the wild, they don't throw their shit so much. In the wild, they smell each other's poop to detect parasites and disease among their barrel. To help keep themselves safe and healthy. Throwing shit is reserved for humans. I'm just saying...

In cultural forms, a small monkey, despite its age, will generally be anthropomorphised as a young child without sexual desire. Even if the figure were to enact such desire, expose her genitals provocatively, this would likely appear as a more or less childlike cabaret to us. To read such a gesture too literally would be close to recognising the monkey's sexual activity as the human's degree zero. It is us full of desperate lust, our secret fear of dignity lost. But here, with a feminine mask, long humanlike hair together with childlike costume, the monkey is a bundle of contradictions. Watching him like this, I want to know what she is thinking, to somehow feel the intensity hidden behind the mask. As if beneath the mask is not a childlike monkey, but a girl who knows what she wants, and who, like Brás Cubas, relishes the salt of mystery and the pepper of danger.[25]

Fredric Jameson describes things like props as apodeictic – as pointing to specific properties or truths, since we immediately assume recognition and denotation on their basis. They are also, however, troubled by Derridean undecidabilities, as he puts it, they are always capable of reversing and undermining intention. This uncertainty, argues Jameson, is productive – 'it makes for the tension between temporality and space which, when maintained to the breaking point, allows us to glimpse the absent centre of this work, the famous Stillstand in which history and the Now are momentarily indistinguishable'.[26] In other words, sometimes a prop is not a prop, when it exceeds its own propness. The *maneki-neko* is one such prop, prodding, scratching at (for this viewer at least) long-held marginal curiosities like: What keeps the *maneki-neko* arm bobbing? Is there a battery? Does it belong to our age or an older one? Is it mechanical or electric or even solar? Do you wind it up, and if so, when was the last time? It also feels slightly authorial, as if whoever or whatever is behind the camera and its editing protocol is distracted by the *maneki-neko* and its

bobbing arm, or wants to make a serious philosophical point about likeness via cats and swinging limbs. As the scholar Paul North writes, 'Between a banality of sameness and a delirium of difference is where likeness hides.'[27]

Real cats never wave their paws in greeting. In English, 'the cat's paw' is an idiom for the dupe, someone taken advantage of or used by another for pleasure and need. How perfect that this idiom is derived from Jean de la Fontaine's seventeenth-century fable 'The Monkey and the Cat', sometimes included in anthologies of Aesop's Fables (fig.3). The difference between Fontaine's depiction and the Aesop version is that in the former the cat is tricked through persuasion while in the latter it is by force. In French the idiom with identical meaning to 'the cat's paw' is *tirer les marrons du feu*, picking up directly from the fable's morality tale, wherein a monkey persuades a cat to pull chestnuts from the fire with the empty promise of sharing the edible treasure. The cat leaves empty-handed, of course, with its paws badly scorched.

The real cat in *Untitled (Human Mask)* is not interested – won't be pulling any chestnuts out of the fire on behalf of this or any other monkey. Perhaps the anthropomorphic costume-wearing fills her with contempt. What she does do (in the brief moments when the camera fixates on her) is that instantly recognisable, excruciatingly enigmatic eye work: slow wincing, dipping and raising his brows, opening and closing his eyes, shoring up her sense of himself, almost as if, speaking, sotto voce: *Are we cats just bored, instinctively?*

The swinging back and forth of the monkey's leg, her head dropped and hidden behind her long wig, is this the sign of introspection? All the time I'm thinking, what a strange orbit all of this rotates within; what a strange desire I have to want to parse it all, have it make sense; and what a strange confusion all of this is rendering. Is, for instance, the monkey missing something, reminiscing, in the middle of a reverie over a pleasure once had, or regretting the ruin of plans just made? Is she composing a thought to share with another monkey? Surely there must be others – friends, family – somewhere? The longer this list of speculative interior states based on the value of her pose (tempered by or perhaps assumed through the featureless mask), the more we become aware of the arbitrariness of these conventional poses everywhere. A tapping foot, a swinging leg, playful kneading, stroking one's hair – what to make of these clues for interior states? Every time the monkey strokes or pulls at his hair, I'm reminded of the absence of my

own. The monkey seems evolutionary close to me (99 per cent shared DNA). Zoographia. Not every animal could wear that costume, that mask, and suggest to us some of the things I have been listing. She sits at one of the tables and fidgets, plays with her hair. Her attire suggest that she should be able to talk but can't; her silence reminds me of my father. He was not a man for words, he spoke little to me unless he was angry. The tender moments were sparse, but I do remember playing chess with him. Chess was something he liked, and he played it with me. Until I was able to beat him, and then we stopped playing. And I would sit, alone at the table where we once played, fidgeting, playing with my hair probably.

The philosopher Henri Bergson thought the essence of comedy was 'the image of something mechanical encrusted upon the living'.[28] A monkey with a wig, a child's long hair, a sailor suit and a white mask. Is that funny? There are circumstances where you could imagine small children in delight at such a spectacle, at least in the days when the circus was more dominant in public life. There seems to be very little that's funny in *Untitled (Human Mask)*. After five or six minutes, I could feel a rising grievance on behalf of the animal. This is something that can happen when you look too long, remain with a thought for a while. The monkey's humiliation reminds us of who we are, in a way that we wish we weren't. It humiliates all of us to allow humiliation to proceed. I think the feeling of humiliation is powerful and productive here, its incitement of awkwardness as we watch is almost too much, pushing each observation back onto us.

At one point, the monkey leans back against the corner of what seems to be a dividing wall. The pose is a graceful recline, as if deep in thought, the light catching the end of her porcelain nose and the cavity of one of his eyes. A piece of hair, beautifully highlighted, falls across the side of her face, most of which remains in shadow. The chiaroscuro here is exquisite; it overcomes the subject of the image and feels like it belongs to the long history of composition, a means of making an image pulse with light and shadow. She plays with his hair, each time with the same apparent curiosity as the time before. *What is this stuff that hangs from the top of my head*? Then a wide shot as she sits at a table, looking towards the camera. Is she looking *at* the camera? What would that even mean? Then, a cut to what seems to be the real object of her vision – a screen imprinted with a mountain view. Is she looking at the view, or the picture?

The monkey is touching the screen and the walls. His mask imposes structure on these (familiar) movements, it supplies an idea of purpose. At one moment she touches the wall and then turns away to touch her hair, as if these were coequal objects of curiosity. (Does she do this every day, with everything, everywhere?) Then he touches the plastic that wraps a forgotten bouquet of flowers. Then he is on to her hands, holding them up, touching, feeling as if he had no idea he had them. *What are these for, I wonder?* And so he goes on: hair, hands, walls, kitchen surfaces, bottles, hot towels, screens. But the one thing she never seems to notice is the strangest of all – the mask she's wearing. This lack of touching is stranger than all the serial touching put together.

Why doesn't the monkey tear off its 'human mask' and wig? The better to transcend irritation and examine these strange objects' particularities. Just as she has done with most everything else. Why not pour over the mask, inside and out, and ask, in her own special way, *What is this thing? What, after all is this?* Perhaps the monkey did pull off its mask and hair many times during the shooting of the film. Maybe it was difficult to keep her focussed; maybe the film's edits hide an even fuller range of the monkey's instinctive curiosity. Maybe, in fact, she is always, every time we see her, on the verge of taking everything off, this *au naturel* concealed beneath every cut.

There is the sound of rain; for a moment it's quite loud. The monkey retrieves a bottle of liquor and places it on a table. She seems to be staring at the bottle. But it's impossible to know what she's actually looking at. We can see the mask's eye holes and speculate, but we can't see the eyes that stare out from behind them. And then the camera starts making super-tasteful compositions, like a television advertisement, perhaps for fine food: out-of-focus objects in the foreground; careful lighting that has everything not quite in shadow.

The monkey seems unaffected by or completely unaware of what we presume to be (or rather not to be) 'the outside'. Perhaps it's a kind of allegory of what it means to be human – always on the verge of not being. After all, being human is a type of achievement; it's certainly not a foregone conclusion that we will remain human. Being human requires structure, order, at least a very rudimentary philosophy of people and things. Otherwise everything is just phenomenological flux, and, butterfly-like, we might be continually distracted by things appearing as others pass

from view. Human experience would be everything all at once, and this 'everything all at once' is deep inside the film.

The monkey, in the absence of the human, is a kind of surrogate form, on the cusp of structure or regressing out of it. Could she have been reborn through metempsychosis, when the souls of extinct humanity pass on secretly, silently to monkeys, cats and cockroaches, so that they can be more than 'almost human' (monkeys), silent company (cats) or perpetual nuisance (cockroaches). According to Ernst Cassirer, humans were once without structure. *Homo sapiens* did not at first understand how things in the world related to each other and had no way of distinguishing between what happens 'in here' and what takes place 'out there'.[29] In *Untitled (Human Mask)*, it's Armageddon outside. Inside, it's all curiosity – things bleeding, one into another, part and whole, living or dead, and when they cease to be in (the monkey's) view, they disappear forever until they come back. Will the monkey ever understand the basic laws of fiction?

Does she recognise that in parallel with her performance on camera there is the real animal who she is, the one who lives and breathes before and after the film's time? That *le personage ... n'est personne*?[30] It's certainly not possible for us, as viewers, to listen to Huyghe and the monkey discussing between takes how she should walk and carry the liquor in frame. Maybe they discussed Tippi Hedren's performance in Hitchcock's *Marnie* (1964) – her walking on the train platform as the camera dolly did a contra zoom behind her. At around the fifteenth minute, the camera tilts down and we see the monkey's prehensile feet, so animal-like, reminding us that she likes to live where she can climb – high, across the heavens, so far and so safe from us.

The monkey looks up. The sound suggests that she is listening intently to the pitter-patter, looking for the source out the window and beyond. But this is a cinematic sleight of hand. Typically in my work I keep away from sound – it can be too strong, too manipulative. But here the manipulation feels right. It draws your attention to the mask as philosophical challenge. Because he is wearing a mask, we really see nothing. Her head is up, but she could be looking down. Or her eyes could be closed. The mask pulls our focus to the question of how and why those things – the look of the eye, the furrow of the brow, the tightness of lips – can have meaning, how they give cultural value to an intention. The mask pulls you to imagine these signs of intention

as being branded, indelibly, on the face of the thing behind the mask. Even though the mask itself has a very narrow range of possibility for displaying much of anything.

The cat has its back to the monkey, who is swinging his legs backwards and forwards with renewed vigour. She starts turning around and around, like a kid, and then drops to the ground, all dizzy. She touches a mirror with its reflections, literalising the metaphor of being touched by an image. What is capturing her attention? The reflection; the shiny, specular surface; the colours? Into the kitchen. There seem to be sounds, from above, outside perhaps. He looks up. I notice here how cinematic continuity is not strictly obeyed: eyelines are crossed between cat and monkey. Do machines not care about suture? There are dead flies, some of which are really quite large, scarily so, trapped between the window and its screen. There are thousands of maggots consuming something left behind. The maggots and the food. These are the leftovers.

The monkey's gestures creep with too much sincerity, as if what she is doing is everything he ever dreamt of. Sometimes watching her can be unsettling, provoking an unexpected, even disturbing somatic effect, a minor bodily convulsion. The French have a good name for this type of thing: *frisson*, its fricative opening almost onomatopoeic and very close to freezing. It's like a *shudder*. I shuddered the first time I watched *Untitled (Human Mask)*.

Frank Kermode, in his last published essay, wrote that a shudder is the horror, or even the beauty, of a body's response to violent stimulus: when you look at something captivating, your body responds.[31] The shudder involves mimesis, an experiential moment when the subject or viewer imitates the object. Adorno gives the example of a subject or viewer's 'goosebumps', when instead of overcoming an object through discourse (for instance, thinking of a field of cows as merely meat or milk), the subject in a sense 'becomes' the object. The shudder describes the subject's being overwhelmed by otherness, horrified by it even, and, for a moment at least, recognising and embracing the impossibility of categorisation. You shudder when shocked by the qualitive thickness of an object or an animal, in a sign of radical recognition; it's the violence that gives birth to subjectivity, hence its physical impression, the marking of your body with a slight, but nevertheless uncontrollable, movement or shiver. The shudder, writes Adorno, 'transforms art into what it is

in-itself, the historical voice of repressed nature, ultimately critical of the principle of the I, the internal agent of repression'.[32] The shudder arrests or, more typically, delays commodification.

Untitled (Human Mask) refuses to let what you see be reduced to its referents: the monkey is not to be abridged through our anthropomorphic projection, with its roots in colonial histories, white supremacy and species domination; the ruined city we see is not just a specific place in the world, Japan, but rather is place in general, in a time perpetual, with a force unthinkable. Kermode identified that W.B. Yeats's 'Leda and the Swan' (1933), that great shudder poem, is also about animals and orgasm:

> *A shudder in the loins engenders there*
> *The broken wall, the burning roof and tower*
> *And Agamemnon dead.*
> > *Being so caught up,*
> *So mastered by the brute blood of the air,*
> *Did she put on his knowledge with his power*
> *Before the indifferent beak could let her drop?*[33]

Can a monkey shudder, I wonder?

Untitled (Human Mask) has a soundtrack, but it's relatively inconspicuous. Apart from the initial plangent buzz of the drone, the woman's voice on the disaster tannoy, and later the sounds of the monkey's rapid footsteps and rain leaking through the roof, nothing much registers. The tannoy voice recurs once we are inside with the monkey, and it pierces the mundanity of the other sounds. It's portentous – in fact, more than portentous. As John Ashbery writes (about poems by Gertrude Stein), it's like 'a piece of music by Webern in which a single note on the celesta suddenly irrigates a whole desert of dry, scratchy sounds in the strings'.[34] There is, of course, sync sound for the monkey's movements, but much of it appears to be what film-makers call 'atmos', or background noise; often gathered after shooting but edited in 'as if'. Atmos is often composition. Here it is the sound of almost nothing – what the world might be like when everything has been quieted.

Of course, we have no idea if what we are hearing is actual sync sound – the drone, the tannoy voice, the tip-tap of rain drops. I can imagine that tannoy voice reaching out into the darkest future, year by year, quieter, less

pronounced, eventually starting to stutter, occasional missing words, the woman's voice dropping an octave or two and slowing transforming into an elongated, barely audible, almost libidinous, moan and then ... silence. Forever. As I watch the film, there are other sounds, inside my head, where it's super noisy. So many voices pulling me one way, only to be knocked out by more anxious others. There is much to think about and much work to be done to enable at least one of those voices to become a sustained, interesting thought. I have to read another book, I say to myself, and re-read another, and also something I saw online. And so it goes. I kick myself for being such a lazy reader, never reading enough. I should be able to read a book a day; that seems reasonable on paper. Each day around four thousand books are published. Assuming that's accurate, if were to read one book a day, as Gabriel Zaid observes, I 'would be neglecting to read four thousand others, published the same day and [my] ignorance would grow four thousand times faster than [my] knowledge'.[35]

Singerie

This is what I see in my dreams about final exams:
two monkeys, chained to the floor, sit on the windowsill,
the sky behind them flutters,
the sea is taking its bath.
The exam is the history of Mankind.
I stammer and hedge.
One monkey stares and listens with mocking disdain,
the other seems to be dreaming away –
but when it's clear I don't know what to say
he prompts me with a gentle
clinking of his chain.
- Wisława Szymborska[36]

In the 1960s, Desmond Morris, of *The Naked Ape* fame,[37] had a primetime TV show called *Zoo Time*. Here he introduced to the world a chimp named Congo, described in the press at the time as an 'abstract expressionist' (fig.4). Congo enjoyed brief celebrity and even had a 'one-monkey show' at the Institute of Contemporary Arts in London. People say that Picasso bought

some of Congo's work, but this strikes me as apocryphal. Salvador Dalí apparently referenced the chimp as a painter once: 'The hand of the chimpanzee is quasi-human; the hand of Jackson Pollock is totally animal!' Although this sounds like one of Dalí's typical provocations, I can find no recorded source for this quote, so it's likely apocryphal too. But this anecdotal storytelling, the citation of real and imagined historical encounters with monkey art, suggests that many people were in on the joke. The joke circles around the idea that if a monkey can do it, anyone can, and yet it took art of the modern era almost four hundred years to get to the exacting and deep intensity of abstraction. If Congo the monkey could achieve this in a few minutes, the fact that artists including Jackson Pollock, Philip Guston, Alma Thomas, Lee Krasner, Jack Whitten, Piet Mondrian, Joan Mitchell and Willem de Kooning came to abstraction through an understanding of the entire history of painting quite simply evidenced wasted time.

Around the time Congo died, another monkey, known as Pierre Brassau, was busy painting different kinds of 'abstract' works, in a hoax perpetuated by Swedish journalist Åke Axelsson, who staged a public exhibition of Brassau's paintings at Gallery Christinae in Göteborg, claiming that they were by a forgotten French artist recently rediscovered. The exhibition was a mischievous trap for clients and critics: Would they be able to tell the difference between a chimp's abstract painting and the 'real thing'? It all gets a bit tedious from here, and only mildly amusing (although one of the first serious art reviews of 'Brassau's' work opened with the observation that the paintings were so bad, it looked as though they had been painted by an ape). What *is* amusing, however, is that Morris's, and even more so Axelsson's, provocations feel themselves like contemporary art of some kind. It is not the kind that draws much of my attention, but its agonistic character is certainly familiar. Actually, if you think about it more carefully, presenting monkey painters as legitimate abstract painters was somewhat like internet art, *avant la lettre*.

The history of art features a fair number of monkeys, some as leading characters, others more as extras. *Singerie*, meaning 'monkey trick', describes a genre of painting showing monkeys mimicking human behaviours. The genre became popular in the sixteenth century (although its theme was once common in ancient Egypt). Practitioners include Pieter van der Borcht, Jan Brueghel the Elder, Titian, David Teniers the Younger and his brother Abraham. And later, Watteau, Nicolas Lancret, George Stubbs, Frida Kahlo

and others. By the eighteenth century, *singerie* had generally evolved into *singe peintre*, depictions of monkeys performing as artists, perhaps satirising the art world ('even a monkey can do this') or making fun of polite society at large, its airs and pomposity. A product of European orientalism, *singerie* paintings certainly catered to the market's colonial predilections.

Jean-Baptiste-Siméon Chardin's *Le Singe peintre* (1740) is my favourite work of *singerie* (fig.5). It is an unusual painting for the genre. And ironic. Chardin is making fun of academic painting, I think, but he spares the monkey its typical humiliation. The monkey, to all intents and purposes, is painting a still life with classical form. So as she paints, she should be looking at the small statue and other small objects spread out compositionally in front of her, the traditional forms of an academic art education. But in fact, not only is she not copying the figurine (no sign on the canvas), she's actually looking at you. She has found you and will paint you. Or will you set her free?

Chardin's *Le Singe peintre* was one of the first works I thought about when I started looking at Huyghe's film. Maybe it was something about the way the sleeve sits on the monkey's arm? Or maybe the prehensile foot on the easel support? But most of all, I think it was because of the monkey's look: it condenses sorrow, pain, curiosity, confidence and plea. It's all of those things and none of them, proving that what she thinks and really knows is *something*, but something *we* will never know. With *Untitled (Human Mask)*, we attempt to understand the monkey's performance by projecting onto its body what we know of human emotional body language, and the mask is central to this mechanism. It's a paradoxical prosthetic: designed to make humans appear more generic, here the mask facilitates our attribution of specific traits to the monkey – human kinds of purpose and style, in spite of its impossible-to-know consciousness.

Compare the stare of Chardin's monkey with the final shot of the monkey in *Untitled (Human Mask)*, an extreme close-up on the monkey's mask, from just below the nose to just above the eyes. In each eye a single bead of reflected light. She is looking at you filming; we see the reflected light of the apparatus, the camera eye that is making all of this appear. Both works, the Huyghe and the Chardin, ask us to consider the difficult and arbitrary way we assign meaning and value to the other – to their gestures, grimaces, physical tics. Because here the monkey is the other, she comes to stand in for other

kinds of cruel, inhumane otherness. Take another example from the mid-eighteenth century: Jean-Baptiste Deshays's *Le Singe peintre (c.1745)* (fig.6). Sharing his title with Chardin, Deshays meticulously references the senior artist's version of the same subject. But Deshays's painting misses the radical quality of Chardin's. The monkey looks not at the viewer but towards the voluptuous naked body of his model. The animal gaze here exceeds the performance of the male gaze, becoming a virtual male animal haze of prejudice and fear, and the provocative whiteness of the model's buttocks codes the monkey racially. The fear and prejudice projected here is the kind that gives birth to resentment and intolerance, what W.E.B. Du Bois calls the 'psychological and public wage of whiteness'.[38] The history of that representation, of a white (sometimes naked) woman desired by the projection of an almost-man beast, sublimates the deepest fear that many white men have, produced by and reproducing a desperate, dangerous racism.

One of the most poignant and riveting recent examples of *singerie* is Gary Winogrand's photograph *Central Park Zoo, New York City, 1967* (fig.7). Here is Hilton Als: '[We] see a white woman and a black man, apparently a couple, holding the product of their most unholy of unions: monkeys. In projecting what we will into this image – about miscegenation, our horror of difference, the forbidden nature of black men with white women – we see the beast that lies in us all.'[39] I read an article recently that revealed that the Black man carrying the monkey and the white woman in the picture did not know each other; their union is simply the effect of photographic composition. Donna Haraway, thinking about all the apes who are not humans, asks what it means to be close to 'almost human'. For Haraway, the Western capitalist interest in primates is steeped in orientalist thinking and it is here that culture, race and gender are constructed, to reinforce and champion the order of things. Here is Haraway:

> *Simian orientalism means that western primatology has been about the construction of the self from the raw material of the other, the appropriation of nature in the production of culture, the ripening of the human from the soil of the animal, the clarity of white from the obscurity of colour, the issue of man from the body of woman, the elevation of gender from the resource of sex, the emergence of mind by the activation of body.*[40]

When a monkey is included in a work of art, it's often in the service of a strong affirmation-through-negation of what it means to be human. *Untitled (Human Mask)* plays with this idea of difference, between humans and monkeys, but also between living and not. Apart from humans, all the species of *Hominoidea* are edging towards extinction, including the tailless monkey in *Untitled (Human Mask)*. If, in the film, humans are now extinct, would monkeys be rescued from imminent extinction – would other species start to 'come back'? Would human-built structures, like the restaurant, become the equivalent of archaeological curiosities for these resurgent species?

Back to the Restaurant

To us art is an adventure into an unknown world, which can be explored only by those willing to take the risks. This world of the imagination is fancy-free and violently opposed to common sense. We favour the simple expression of the complex thought. We are for the large shape because it has the impact of the unequivocal. We wish to reassert the picture plane. We are for flat forms because they destroy illusion and reveal truth.
– Mark Rothko and Adolph Gottlieb[41]

Question: What animal would you be if you could be an animal?'
Answer: 'You already are an animal'.
– Douglas Coupland[42]

Huyghe's ruined restaurant is shorthand for human life suddenly disappeared. It's a special kind of abandonment, without specific reason. We recognise this visual signature – emptied towns, destroyed buildings, piles of garbage – from contemporary depictions of Armageddon. Superpowers staving off imminent ends, courtesy of Marvel et al., have fittingly been the cinema's swansong, keeping screens packed worldwide right up until their closure due to Covid-19. The world in Huyghe's enigmatic scenario exhibits what Eugene Thacker refers to as 'hiddenness'. It's not that the world is hiding from us, as this would suggest that all we have to do for it to be revealed is un-hide it. Rather, *Untitled (Human Mask)* reveals to us the remainder that cannot be revealed, that is beyond our ability to imagine – what Thacker names as 'the-world-in-itself'. This is the paradoxical condi-

tion of Huyghe's film: *Untitled (Human Mask)* depicts a world *without* us rather than a world *for* us, but such a world is impossible to depict. We would of course have to have been there, making it once again the world *for* us. We can only, I think, hope to resolve this problem by conceiving of the camera and its entire apparatus – including editing and sound – as autonomous. As though for years the camera had been drawn ineluctably into the city's orbit of natural animation processes and innovation, contemplating a future where it would be both master and subject. Now it is all agency and possibility, and for the monkey, the cat, the cockroach and the maggots, their world has become a wholly autonomous moving-image spectacle.

Thacker points out that the horror genre is not simply about fear, but also 'the enigmatic thought of the unknown'.[43] In this enigmatic regard, *Untitled (Human Mask)* is, more than anything else perhaps, a horror film. We are afraid of the *world without us*, says Thacker, because it escapes our ability to conceive. Nuclear war and global warming hint at what that world *might be like*, but the entirely post-human is an unmanageable, impossible phantom. *Untitled (Human Mask)* chases that spectre's tale and fills this viewer, at least, with dread. It is a dread that destroys thought and reduces human to animal. Yet as the possibility grips us with terror, it increasingly defines us.

When we began the Afterall *One Work* book series fifteen years ago, we agreed that an artwork needed to be at least ten years old in order for writers to reasonably judge its importance, effect and influence. These latter things can change quickly and resonate differently across time, and a work that carries obvious promise on day one might shrink into relative insignificance some years later. A *One Work* ages into its importance, gaining strength ex post facto. As I write, on the tenth anniversary of the 11 March 2011 earthquake in Japan, I am reminded that we made an exception for 2014 work *Untitled (Human Mask)*. This reinforces reflections I've had about my delay in starting this text, and my surprise at discovering how much my thoughts and feelings about the work have changed since I first saw it.

I still like *Untitled (Human Mask)* today, as much as I did before. The impressions it makes are rich and provocative, but they have necessarily changed, or been transformed in the intervening years since 2014. A lot has happened since I first encountered the film. Most important has been the growing importance of Black Lives Matter, particularly after the murder of

George Floyd, and its long-overdue account of white middle-class complicity in racial division and repression. Covid-19 has transformed the body politic, issuing the further exposure of racial inequality. There has also been the democratisation of discomfort, now an essential part of interesting artistic and intellectual life, encouraged and given critical energy through Black Lives Matter. There is now the growing sense that we might be living through a fin-de-siècle moment, perhaps our final one, with racist, populist governments now firmly in place in the UK, France, Brazil, Israel and other places we once assumed knew better. In 1853, the anti-slavery campaigner and Unitarian minister Theodore Parker wrote: '[L]ook at the facts of the world. You see a continual and progressive triumph of the right. I do not pretend to understand the moral universe [...]. But from what I see I am sure it bends towards justice.'[44] These words, later distilled by Martin Luther King, Jr, as 'the arc of the moral universe is long but it bends toward justice', were ordered woven into an Oval Office rug by President Barack Obama.[45] These are words that have obviously had to fend off much evidence to the contrary. As if the universe had its own cynosure – a light of goodness and virtue, guiding everything, despite all efforts, good or bad. I think that's what I thought even a year or two ago. I have learned many new facts since. As a result, I don't spend too much time here discussing the reference to Noh theatre, something I would no doubt have written about copiously some five years ago. Today that reference seems a little mannered and has to compete for attention with lots of other ideas and suggestions that are referenced in the work more strongly now than when it was first made.

This gets to the heart of the idea behind the *One Work* series and its inherent productive contradiction: an original and influential work of art achieves its originality and influence through imitation; by absorbing and building on inventions rendered and lessons learned from other works, as well as engaging with the rhetorical ballet of their accumulated critical enterprises. For most artists, to make a work of art is to engage with materials without really knowing how and why they are doing it. Forms obey their own rules, and imitation, repetition and influence can emerge quite unexpectedly. I have always loved Georges Didi-Huberman's description of this nexus of confusion: 'In the work of art, everything is presented as a kind of self-evidence, while nevertheless remaining obscure.'[46] In this scenario, there is no work of art a priori. Making work like this is an example of the

Greek notion of *hexis*: doing something without being fully conscious of what you are doing and only discovering and learning from what you have done afterwards, and even then never fully learning its lessons. Proof of this effect lies in the recognition of the work as a 'good' work of art, and not, say, as a lump of coal soon to be dispersed as temporary heat and residual soot (though, of course, under certain circumstances this too could constitute a work). And then the work exists, perhaps as a model for an exemplary way of doing things, a contemporary disposition, and it begins to spread its influence, gathering imitators and imitations.

The *One Work* series was conceived in part as a way of thinking through how innovatively a consummate work of art repeats and refines its antecedents, and how much it passes on its successful imitation and invention to works that come after. To be original, then, is to imitate and be imitated in turn. There is some kind of ghost in the machine here. I'm writing most of this text on my phone using the Notes app. And every time I type 'how much it passes on', the software overrules me and composes instead 'how odd is that!' The only way I can overrule this algorithmic tic is by adding temporary punctuation, as in, 'how much it passes. On.' Now, how odd is that? A form of surrealist disruption at the heart of digital predictive imitation? A cry for help from the text itself – asking, demanding, that it be freed from a strict accumulation of quotes and steals? Or simply the imposition of a rigorous, machine-honed demand to hew closely to repeated thoughts; specifically well-oiled phrases, down to and including conjunctive precision? Strange and strangely revealing.

At the heart of Huyghe's work there is an Ur-text on the idea of imitation itself: the idiomatic 'monkey see, monkey do'. Originating in the US in the 1920s, this saying roughly translates into the idea of learning without understanding. It predicates the monkey's second-level status as imitator, casting doubt on anything creative it might achieve. While the reductive summary of animals is part of human self-definition, the monkey is, in this regard, a special case. It behaves almost like a human, but not quite. Its repetition and apparent imitation of some of the ways we are in the world can be very disturbing, and we can have no idea whether this mimicry is essential or trained. We mock the animal because we can't ourselves bear its representation as imitator. What if that is all we are – prisoners of repetition? The word 'ape' even creeps into aesthetic discourse: 'the artist is aping nature' is an obvious

disparagement, by way of an old story, of the production of simulacra without refraction by genius. René Descartes claimed that a perfect imitator was close to an automaton. Take note of the small space of possibility here hinted at by the use of the adjective 'close'. Racist ideology has claimed that Black writers and artists have no tradition to draw upon and that their works therefore lack originality. Quite apart from the naked racism, it's also a piece of philosophical nonsense: *Black artists and writers are condemned as imitators because they have no tradition to imitate.*

The best works of art impose confusion, beg for new readings, repurpose things, foreground the historical underpinnings of earlier readings, underline how provisional they always were. I suppose I'm simply saying they stand the test of time and they are contemporary many more times than once. Re-reading a book, re-watching a film you once loved and now want to share that affection for, can be surprising, sometimes a bit embarrassing. During lockdown, my wife Janice and I watched the 1980 parody film *Airplane!* with our son Oak. I was pretty startled to discover that some things I once laughed at now seem uncomfortably racist and misogynist. Did people really think the scene with subtitles added to African Americans speaking jive was funny? Our son didn't find it amusing; in fact, it annoyed him. I felt a bit ashamed. Watching this film again was an uncanny encounter with a version of myself I no longer recognise.

'The past is a foreign country; they do things differently there' is the famous opening line of L.P. Hartley's novel *The Go-Between* (1953). It describes the experience of finding evidence of your past, and how, while somehow aware that this past has marked you significantly, often badly, you can no longer recognise it. The past may be foreign, but it's shaped by today and its strangeness is made less shocking by our selective curiosity about it. In fact, the past of memory is always about the present of the rememberer, the different person she has become. Memory believes before knowing remembers. Leo, the narrator of *The Go-Between*, is in his mid-sixties, retired and easing into his final days, when he discovers a box stuffed with a congeries of his long-forgotten past. It all feels strange to him, as if it makes sense but belongs to someone else – not just anyone, but a person *he no longer is*. He starts to read one of the old diaries he finds in the box, and the novel springs to life. *The Go-Between* sketches out ordinary action as it either reveals or conceals mythic meaning and purpose. It also reminds us that the future patronises

our experiences, so much so that we conveniently forget the past and become generally uncurious as to how it continues to define us. E.P. Thompson has described this condition as the enormous condescension of posterity.[47] The past today is more capacious than ever and the extent to which it is collected grows exponentially. Your phone for instance, has become both the narrator and curator of your past lives. It knows you so much better than you know yourself; and almost every day your phone probably presents you with a 'memory' – a collection of images and films of one of the many people you once were. This person feels more foreign than ever, no matter how virtually close you stick to them.

For the longest time, the dominant conception of the past was as more or less continuous with the present, and the most you could hope for was to repeat it at its best, sifting through its models in ruins. Into the nineteenth century, the past becomes more and more allegorical, its research and development an imperfect but necessary trial, a flawed dry run for our more perfect today. It is deeply ideological – the shaping and interpretation of the past to promote the mythical idea that capitalism as embryo was always already coiled tightly inside the very earliest of human social structures. The past here becomes a validation for the present, confirmation of the virtue of the path taken. The British government's demand this year that monuments to rebarbative historical characters remain upright and rigid helps define the past as a sacred precursor of contemporary capital: the past is a protected 'heritage', even if this heritage is one of dubious or now rejected truths. Each year we discover new connections to the past, new histories, new origins stories, as older truths are overturned. We learn about gene flow events (sex between different species of primates) that indicate we are more than 2 per cent Neanderthal. We are also a not-insignificant amount of a ghost species, extinct except for a few footprints discovered in the sand. Everything is always only provisionally and conditionally correct, yet capitalist stagecraft has been persuasive: history has been written so that ancient cultures appear as pre-forms, sympathetically predisposed for their capitalist futures. From theories of evolution to stories about transitioning from nomadic life, many long-held truths are revealed as motivated magical thinking, working hard to hypostatise our contemporary political economy. We are potentially full of complexity and contradiction, but forced to be a small percentage of ourselves.

A mask-wearing monkey could be a metaphor for the theatrical commentary that has always accompanied this manipulation, giving form to alternative narratives while revealing the fragility and nonsense of others. This is a history of optimistic and critical reflections on difference, how things could be otherwise. From Ancient Greek theatre through Noh theatre, commedia dell'arte, African Dance theatre, South American Indigenous theatre and all the way to *Untitled (Human Mask)*, masks engender dialogical thought and reveal the robustness of fantasy, how it can enable resistance as well as play.

I read the other day that monkeys and other wild animals have come back in large numbers to parts of Fukushima. It's similar to Chernobyl, apparently – the wild animals living mainly in the radiation-contaminated, off-limits wooded areas, but from time to time wandering into abandoned villages and small towns as if they own them. Did the monkey grab her mask and hair on the way into the restaurant? Was this the first time, or does she always transform in this place? The longer the film goes on, the more its restaurant world feels like an old-fashioned cabinet of curiosities. In the sixteenth century, when the novelty of the *Wunderkammer* was at its height in Europe, visitors to homes and museums were invited to touch and feel the objects, take in their strangeness with tactile curiosity. *Untitled (Human Mask)* depicts the monkey is if she were inside of such a cabinet: everything, including his own body, seems like a strangeness without obvious signification.

My friend Mick thinks the digital diaspora is abducting gesture, perhaps a perfect description for a very difficult and complex condition. Gesture is what protects us, allows for pauses, circumspection, another way of reading each other. The monkey in *Untitled (Human Mask)* exhibits a lot of gesture. The monkey tries to write her own story through complex articulations of her body, attached to an intense curiosity. But gesture can also diminish, if an attached meaning reduces the subject to stereotype, undermining the subject's self-worth. This record of how gesture works is captured by the other star of Huyghe's production: the contemporary camera. The camera seems as curious about the monkey's gestures as the monkey is about all the things that distract him.

The gesture-less mask makes it seem as if the monkey is perpetually in deep thought. The mask flattens out and removes hesitation, distraction, boredom. I'm wondering all the time as I watch: What can she be thinking?

Perhaps, given the presumed end of humanity going on outside, he's thinking that the human species never really gave birth to anything; that they only took lives, and eventually took their own. Descartes thought that monkeys and humans had almost identical brains, except for the penal gland, pea-sized or less, living secretly in the centre of the human brain. The penal gland, according to Descartes, is the soul, what gives us our difference, all of our human intelligence, our ability to cry, love, argue and, importantly, to feel shame. Jacques Derrida says shame is a human-beast differential test.

In *The Animal That Therefore I Am* (2002), Derrida describes the shame he feels when an animal sees him naked:

> *I often ask myself, just to see who I am - and who I am (following) at the moment when, caught naked, in silence, by the gaze of an animal, for example the eyes of the cat, I have trouble, yes, a bad time overcoming my embarrassment. [...] It is as if I were ashamed, therefore naked in front of this cat, but also ashamed for being ashamed.*[48]

Clothing is proper to humans; no other animal would bother. They feel none of the shame that we do at our nakedness, they don't overinvest in the sight of genitals. They are naked without even knowing it. What is Derrida ashamed of? 'Ashamed of being as naked as a beast.'[49] But a beast *cannot* be naked, if it has no idea of what 'not naked' is; perhaps being naked for it is much like being clothed for us. Would a monkey ever arrive for dinner without first making sure she was naked? Ham, son of Noah, sees his father naked and as a consequence is cursed. Ham is forced into exile and his descendants continue to carry that curse. With typical malevolence, European Christianity, through the middle ages and into the Enlightenment, considered Africans to be the descendants of Ham; subjection, hatred and fear of African people was considered justified on the back of this original curse.

Why is the mask white? Monkeys are almost never 'white', the exception being the rare white spider monkeys of Central America. In traditional Noh theatre, a white *onna-men* (mask) is typically worn by men to signify that they are playing a woman of refined character.[50] But a white mask can also be whiteface. This never occurred to me when I first encountered *Untitled (Human Mask)* and watched it over and over again in preparation for writing this book; yet it certainly does now.

In the 1890s, Bob Cole, an African American performer, radically parodied blackface minstrel shows by creating the character Willy Wayside – an African American man who 'whited up' his own face. Cole's most famous play was *A Trip to Coontown* (1898). By all accounts the play was a defiantly political theatrical act, drawing attention to white racism. Whiteface has always been about Black performers placing themselves in a critical relationship to race and class and how these are represented. When Cole became whiteface Willie Wayside, he satirised racial difference without insulting his white subject. As theatre historian David Krasner writes:

> *Acting in whiteface was indeed a bold act, an articulation of racial difference that dislodged a colonial representation that for generations framed the idea of race. [...] Cole's whiteface performance disrupted the fixed stereotype, creating a transience that interrupted the steady stream of cultural signifiers aimed at reducing African Americans to ridicule.*[51]

In 1965, Douglas Turner Ward, playwright and co-founder of the Negro Ensemble Company in New York, produced *Day of Absence,* a one-act 're-verse minstrel' show (fig.8). The African American actors in *Day of Absence* wore whiteface to depict the white racist residents of a southern US town on a day when all the Black people inexplicably disappear. 'The South has always been glued together by the uninterrupted presence of its darkies', declares the mayor. 'No telling how unstuck we might git if things keep on like they have.'[52] Since whiteface is a protest against blackface and the culture that birthed it, the white mask in *Untitled (Human Mask)* makes you think of blackface. How could it not?

Film Consciousness

Time was a film run backward. Suns fled and ten million moons fled after them.
– Ray Bradbury[53]

Untitled (Human Mask) is in many respects a typical, almost ordinary film. Its look, its compositions, technique and topicality are easily recognisable. It

brings together (at least) one camera; a main subject (an anthropomorphic monkey, a 'reverse-furry'); some extras (cat, larvae, cockroach); a vague scenario (monkey inhabits human world without humans); familiar shooting and editing styles (quick cuts between wide, medium and close-up shots; narrow depth of field; careful, polite lighting); a 'serious', meaningful aspect ratio (cinemascope); and a catastrophic backstory (prologue of urban devastation, possible human extinction). Everything 'works': there is no immediate sign of abstraction or distraction; camera takes are neither too long nor too short. Apart from its length (on the long side for an 'art film'[54] but short for a movie), it's familiar and understandable *as a film*. There is no optical or formal revolution or lesser representational disturbance. No ontological challenge for art, no demand that we consider its expanded field. It is a traditional filmic form, but one that quietly masks a radical experiment in archiving something: *what it might be like to be like something else when that something else has all but disappeared*. It archives, let's say, the cinematic for a post-extinction world.

This cinematic *mise en scène* is the depiction signature of the twentieth century. In its 'proper' place, the cinema, the *mise en scène* is what Raymond Bellour has called an exemplary 'successful installation'; its workings, tricks and unique *trompe l'oeil* effect were familiar to all and understood by most. This effect was fully formed by the 1950s, but by then already beginning its long decline. It was consumed and superseded first by television and later by the complex digital media of our contemporary world. Its invention and universal adoption, however, have been transformative for the perception and organisation of the world that binds us all together in some way, and equally revolutionary for self-presentation – how we engage with that world *in the knowledge of*. It's virtually impossible for us to think of how the world might have been 'before' the cinema.

Imagine, for a moment, you are walking down a busy city street around 1895. It's windy and you are clutching your coat close with one hand while the other holds your hat to your head. Out of the corner of your eye you see three men standing around a black box mounted on three legs. One of the men is turning a crank on the side while he looks over the top of the box. You recognise that the box is a motion-picture camera. It's the first time you have ever seen one being used. You realise that a movie is being made, of you. For you, this is new and you are startled. You let go of your hat and the wind sweeps it

away, out of frame. You laugh. Who wouldn't? You have been thrown off balance by the realisation that a moving image of yourself, *surnaturel*, has split from you. You have now bifurcated, and the precipitating event is a beautiful, foundational moment of pure comedy. This moving-image reproduction of you in comedic full flow, free of corporeality, will circulate into the future and continue most likely long after you are gone. And once you know this, your every action, tick, gesture, mood will increasingly become subject to careful consideration, always in preparation for the next time. A spectre has been born and henceforth you are now *you and your moving-image self*, with your moving-image avatar taking permanent residency inside of you.

This is the selfie's primal scene. Today's apps that make you look like a perfect model of yourself, the plastic surgeries that motivate and are motivated by this tendency towards perfection, begin their invention here. When people first began to understand that images of themselves moving, detached from their bodies, like their very souls, could live alone in the world without them, they could not have known the extent to which we would increasingly chase the lure of this effect. That this new object of attention would become our near total distraction. Films began as the anthropological desire to *show the world to the world*, but some got bored of the real world and tried to create a better one on-screen.

Untitled (Human Mask) is the emplotment of the world condition prior to, but also at the moment of, familiarisation and assimilation with the cinematic *mise en scène*. Watching it in this way, embracing fully the preternatural condition that the film itself sketches as possibility, is to imagine how it might have been at that moment; to fantastically reify the cusp of the invention of the *successful installation*. In fact, we might even suppose that *Untitled (Human Mask)* is an origin story, if an unlikely one for sure. For the actors or participants, each time is the first time. The film loops so that it will forever repeat this allegory of the cusp moment, prior to our moving-image world. It is a moment none of us can return to (even that Edenic desire to 'go back' is developed and formed inside of the cinematic experience), but which we might enjoy imagining. Think here of all the thousands and thousands of 'period drama' films. *That's* what the 'pre-cinematic' looks like in film – fully cinematic.

Untitled (Human Mask) is a work about what it means to be presented and defined as cinematic. This presentation, this definition, is an integral

part of our contemporary *amour propre*. We are indivisible from it; our existence as subjects is built inside of it. *Untitled (Human Mask)* depicts the mythical foundational moment I have just described, immediately *prior* to its extensive narcissistic inculcation, and *after* the disappearance of the last person able to recognise the condition. For the masked monkey it seems to us like pure repetition, playing endlessly, infinitely without human interpretation or intervention. If animals persist but their evolution does not bring them an ability to perceive what that persistence means, then the moving-image ghosts of these animals remain a kind of science fiction – a flicker of chiaroscuro that no extant life can recognise.

Not one person alive today lives in a pre-cinematic world; there is next to no one who does not have at least some idea that who they are, what they do and how they think can appear as a two-dimensional form in time. We are each at least vaguely aware how the flick of a hand, an adjustment of hair, the tucking in of a shirt, a tender sexual act or even an act of violence can feature as a flat imitation, either on a large screen or on devices in our hands. We are all imitators now. And this is the great knot at the heart of the performance in Huyghe's film – it's an imitation by those who don't know what it is to imitate, who carry on delivering imitation without that knowledge. Animals obviously mimic. But what they cannot do, as far as we are aware, is what Phoebe, in Shakespeare's *As You Like It*, can do: pretend to pretend, grasp imitation in their hands and imitate imitation.

> *Now counterfeit to swoon; why, now fall down;*
> *Or if thou canst not, O, for shame, for shame,*
> *Lie not, to say mine eyes are murderers!*[55]

John Ashbery, writing about Gertrude Stein's *Stanzas in Mediation* (written 1932, published 1956), offered a complementary thought in his description of how Stein's best lines attempt to do what can't be done:

> *to create a counterfeit of reality more real than reality. And if, on laying the book aside, we feel that it is still impossible to accomplish the impossible, we are also left with the conviction that it is the only thing worth trying to do.*[56]

The original transformation of consciousness achieved through the introduction of the moving picture was continued through cinema's opening up of further perceptive possibilities: to see things in slow motion or sometimes upside down, or to witness an animated face in close-up, as large, radiant and star-like. But perhaps the cinema's most significant and in retrospect most revolutionary invention was the ability to show the world running backwards. Cinema introduced temporal plasticity, and reverse movement forces us to abandon all thought of instantaneity. A reverse sequence demands thought. I introduce this invention here because I believe *Untitled (Human Mask)* begs to be run backwards, back beyond its beginning, in order to reveal how they ended up there: the monkey, the cat, the cockroach, the maggots and the camera. To find out how they ended up alone. This looking back would reveal a contradiction. Back 'then' no one knew what was going to happen. History is complete mayhem, for animals as much as humans. It's all competing interests incoherently resolved through the madness of the everyday. Retrospectively, of course, you can make anything seem coherent. That's what films can do. That's what *Untitled (Human Mask)* refuses to do.

We are the Invention of Animals

What, then, is time? If no one asks me, I know; if I wish to explain it to one who asks, I know not.
– Saint Augustine[57]

Max Ophüls's film shooting style is like pellucid prose: graceful, deliberate, calming even as it disrupts convention and reveals radical invention. From the 1920s onwards he re-staged the invention of cinema inside of stories about the vitality and changing textures of modern life. Each of his films can be considered a provocative statement about the possibility of moving images – what they can do, the techniques and ideas they produce and provoke. His films recognise or anticipate the eventual solitary and independent life of the camera, how it will learn from life and then be free of its foundational constraints. In other words, Ophüls's camera considers a future of sentience, even desire. It's a potential now realised everywhere, and it's a potential that *Untitled (Human Mask)*'s camera is trying out for size. In Ophüls's films, you see the rendering of this future camera life, how it can become distracted

by all things that remind it of itself: the giant mirrors and reflective surfaces that produce their own cinematic magic; the dancing bodies and shadows that densely populate social scenes, driving the camera frame to dizzyingly metamorphose. Ophüls's camera moves magically through walls and other obstacles as if these don't exist; it periodically 'stands back' and takes it all in, as if proud and curious about the cinematic 'magic' it has just presented. One of Ophüls's finest films is the anthology film *Le Plaisir* (1952), derived from three short stories by Guy de Maupassant. Of particular interest is 'Le Masque', the first in the anthology.

'Le Masque' opens with a dance hall that possibly doubles as a brothel, filled with excited people dancing, flirting, watching, making love, spinning with excitement. It's pure pleasure everywhere – in bodies, in objects, in the camera's libidinous perambulations. Everywhere there are mirrors, cubicles, balconies for watching, multiple floors, corridors for 'inadvertent' touching and frisking. It's frenetic and unstable, excitement oozes from every element and every person. The camera glides through the spaces with effortless grace. As Michael Wood describes it, the camera has 'the gaze of a curious but unobtrusive god'.[58] It can't stop moving as it discovers an infinite array of fascination. Into the fray enters a conspicuous figure in top hat and tails. He throws off his scarf and coat and immediately starts dancing and hopping frenetically. He seems strangely hybrid: half man, half automaton. He wears a mask very similar to the one worn by the monkey in Huyghe's film. Attached to the dancer's mask, though, is a Charlie McCarthy monocle, the sign of a dandy that accentuates the rigidity of the (porcelain?) face.[59] It has the effect of making the man look like a young person trying to pass off as an adult (with his artificial whiskers). Suddenly he collapses to the floor with exhaustion. His mask is removed by a doctor and he is revealed to be very old and frail – an old man pretending to be a young man who in turn is pretending to be someone older. It's a hall-of-mirrors deception, matching all the dizzyingly, blindingly reflective surfaces of the dance hall. We never see the monkey's face in *Untitled (Human Mask)*, and I realise as I'm writing that I know nothing about the monkey's age. I know nothing about how monkeys age in general, whether their faces betray the ravages of time recognisably, like humans' do. I don't even know how long monkeys live, in captivity or in the wild.

The silence of animals, the fact that they can't speak to us, share their feelings, open up, is troubling. We might want to know what they might want

to say to us, but they won't say anything, so we can't. We can only repeat our mistakes on them and, in the end, be silently grateful that they don't call us out; and in fact, don't *take* us out. As Verlyn Klinkenborg writes:

> *What we have to say about other species on this planet, not surprisingly, is completely out of proportion to what they have to say about us. This piques our vanity, and it blinds us to an important point [...] in ecological, climatic, and evolutionary terms, we are the invention of animals.*[60]

And suddenly it feels like night, or at least it's dark in the restaurant. The monkey sits at the table. Everything here reads to me like *her* contemplation. He looks up, a gesture that doubles down on this interior possibility. *What does he want from me?* she's thinking, perhaps about the director's instructions given to her, via the monkey handler, just moments earlier in preparation for her medium close-up. 'Just be yourself; you are stuck in a restaurant with only a cat for company, who doesn't even like you.' *Where has everyone gone?* the monkey wonders. And then, in frustration, *Does this guy work for the circus or the zoo? Anyway, my consent is manufactured (Noam Chomsky), engineered (Walter Lippman), subject to hegemonic common sense (Antonio Gramsci).* This private critical discourse could be that of all captive animals dressed up, wearing masks and wigs and performing for others. How much of what we see here is actually *hexis* – something he's done before and doesn't even think about now? Perhaps she doesn't know he's doing what he does. Or perhaps she is a critical reader.

The camera inside is different, works differently. Outside it was all measured, mechanical, automatic. Inside there are tripod shots and Steadicam, with the latter's familiar drift, as if the camera were taking a measure. The Steadicam was invented in 1975 to enable dolly-like shots for difficult locations and small budgets. But along the way it invented a whole new look, passing effortlessly from one place to another, gently breathing to and fro. It's a cyborg camera that has slowly, surreptitiously seized formal authorship of the look of much television and cinema. Its quality of visual movement, somewhere between a glide and a gentle sway, has helped define a particular age of beholding, shaping how we experience the world through moving images. I never understood it quite like this before, but the camera in *Untitled*

(Human Mask) has made me reflect on the history of that particular frame; how it was born of economy but – as if gripped by a subtle alien force – repurposed for discovery, horror and fear. The monkey rushes over to the hot towel cabinet. The fridge light is on. There's still power.

Conclusion

There they are. The objects that comprehend my world, and here I am unable to name them anymore – an ornithologist to whom all birds have identical feathers, a gardener whose flowers are all alike. Do you think, the man said earnestly, that's my malady? My disease, provided it is a disease?
– Alfred Hayes[61]

Then she touches the window screen, printed with an image of some forest. She traces some of the drawing and then strokes her hair. Is he making an assessment? Wondering why the forest is two-dimensional and not three-? Or is it just a visual noise that attracts her attention, like she is a baby playing with a toy. Learning. But learning what? As I wrote that, I was watching the monkey play with the plastic that wraps the flowers, then with his fingers. Is she cleaning her nails? She's doing what I do when I'm trying not to work.

As I try to write what I'm hoping is my conclusion, thinking intensely about *Untitled (Human Mask)*, I'm reminded of, distracted by, the fantasy of another not-yet-made project of mine. *Five Years* takes its title from David Bowie's 1972 song of the same name.[62] *Five Years* imagines a world where everyone has already come to terms with the fact of human extinction in, well … five years. They have the date and they are reconciled. The cause is not discussed; a quiet acceptance floats over most everybody and everything. We live, said Joseph Conrad, in the brief interlude between thousands, millions of years of darkness and the darkness yet to come. Extinction, then, should really be no big deal.

Who was it that asked why we are frightened only of the darkness ahead, and not of the huge frightening void before we were born? Surely both should be just as scary. Of course, we've been shielded from these existential threats by our very existence, the anthropic shadow that we cast across the universe. The fact that we are here means that extinction has not happened,

and this modest fact protects us from its likelihood. Just as we are all pro-
tected from death by being alive. It's very hard to make friends with death.
Here is Epicurus:

> *If I am, then death is not. If death is, then I am not.*

And Samuel ibn Naghrillah, eleventh-century poet and warrior:

> *For my part, there is no difference at all between my own days which
> have gone by and the distant days of Noah about which I have heard.
> I have nothing in the world but the hour in which I am; it pauses for a
> moment, and then, like a cloud, moves on.*[63]

Five Years imagines, then, the loosening grip of the anthropic fantasy and
the embrace of Conrad's real. There is no reason why an end like the one that
hangs like a cloud of difference in Huyghe's film should happen in the future.
It's just as likely to happen now, or even in the past. Yogi Berra's apocryphal
nonsensical common sense now makes perfect sense: 'It's difficult to make
predictions, especially about the future.' If you were to die suddenly, from
a heart attack – *she was dead before she hit the ground* – you would never
know if it was personal or an extinction event. Ratiocination is irrelevant.
A catastrophic event, as *Untitled (Human Mask)* is at pains to underline, is
an actual catastrophe. If it really came, the lights could just go out and no
one would ever know. Except maybe a monkey, a cat, some larvae and a
cockroach. They and their progeny would have time to ponder. And if the
universe is forever, then let's leave a record of the best we are. It could map,
record, document, above all make something meaningful and legible of our
earth, its wonder and magic. When we disappear, *our* earth ceases and *the*
earth becomes a planet again, and it will carry, as it always has, its history of
inhabitations, as a build-up of archaeological evidence, and even our brief
troubled presence will leave signs and sediment. All this to greet some imag-
ined visitors 999 million years after our almost certain extinction, to guide
them through some things we have done.

If I were in charge of the Ministry for the Future,[64] I would want to keep
part of our world, to preserve it in some way so that if, a billion years from
now, an alien species were to stumble upon the ruins of our extinction they

would find this record of one of our successful forms. Huyghe's *Untitled (Human Mask)* is a film for and of that record, presenting, looping, perpetually playing as a virtual welcome to visiting forms: *Look*, it could be saying, *we did stuff like this, as we puzzled at what it was like to be almost like something else.* What distinguishes us from monkeys? Simply the 'the privilege of absurdity'.[65] That's how crazy all of this is. If we were to build temples to our hopes and loves, replicating everything, imagining visitors billions of years from now discovering these temples and learning, would we not want one such temple to be devoted to the cinematic effect, marking and revealing the radical discontinuity of self and moving image? The cinema represents a communion of pleasure across much of the world: everyone in thrall to what most everyone else is in thrall to. Not equally, of course – there have been deliberate exclusions, monstrous stereotypes, egregious defilement of non-whites, women, anyone subjugated by ruling classes. But movies have been made in vastly different cultures by vastly different kinds of people, and that, in my view, counts for something.

Untitled (Human Mask) is a depiction of, and speculation on, 'something' that brings the future and the past together. Without human presence, distraction appears decidedly curious and old-fashioned, as if it suggested your first time looking at things, turning them over carefully in your hands, wondering what it is about your leg that keeps swinging, retrieving towels from hot towel cabinets, sitting at the table, alone except for a cat who ignores you. This monkey is the future, except he has not yet discovered the cinema, nor any of the other moving-image developments that distracted everyone in the before. She has the things of the world as things for her to hold, touch and contemplate. Depicted here is a world that disrupts what Hollis Frampton once wrote about as the supreme 'ritual of possession, the creation of possessable things, the conservation of the possessable, the ritual process by which the things of the world and then their reproductions or representations are validated so that they can become ownable, so that they can become possessable'.[66] In *Untitled (Human Mask)*, no living being owns anything anymore. Everything is something, but not for anyone in particular.

The film creates a subtle intervention in what some people call the 'post-phenomenological', describing a condition where all human life is premised on and shaped by digital technologies; a condition in which the thing itself is only a thing because of digital metrics that circumscribe and reveal it.

There is a kind of brutal sense of thingness in *Untitled (Human Mask)*: everything is reduced to its phenomenological presence, and for the monkey at least, nothing seems to stand in for something else. Imagine a world, then, without metaphor. Is that world not the post-apocalypse, the great revelation? The end of interpretation? A world that hovers somewhere between the mundane and the miraculous, before the digital world, before humans discovered the cinema, before their selves and images split? Before the fall, really? A world without metaphor would be a world where the fantasy of capitalist inevitability had not yet been inscribed (ex post facto) on all of history. *Untitled (Human Mask)*'s poetics tug at our collective sense of epochal discomfort, at our increasing realisation that Wallace Stevens's famous, oft-quoted line that 'the great poems of heaven and hell have been written and the great poem of earth remains to be written'[67] might remain intact for the rest of our time; that the great poem of earth will never be written because it would necessarily be a lie. If it is a fool's errand to believe in such a poem, as Adorno suggested after Auschwitz, then we are forced to confront the horror of our own inhabitation of a world that returns our gaze with a violence as unpredictable as ours is predictable. The only thing we know for sure, in Michel Serres's gloomy words, is that if 'persons sometimes kill, the collective always kills'.[68]

Huyghe's film reminds us of the radical transformations that hope and care have made, how the future as motif and siren call has been thoroughly trashed. But it also suggests we *can* still imagine. The fact that the end of hope and care is represented by a strange and even cruel fantasy means that there is, buried somewhere, an alternate reality, where most of us stop killing and destroying, and we no longer listen to those who continue to want us to do so. There is a kind of kitsch to our world, a cheapening and erasure, often violent and without careful consideration, of our best achievements. We need to make work for a better a time. In that way we can leave the dangers of kitsch behind.

Everything that I have written here, all the fragments and tangents, came to me when I was thinking about Pierre Huyghe's *Untitled (Human Mask)*. All of these are things I thought about through his work. I learned a lot, and a lot of things got unlearned. I think that's really all you can hope for when you look at a work of art. For me the writing of this book has been an opportunity not only to engage with *this* work, but also to imagine other works that might have been and ideas I had never even considered before.

I let *Untitled (Human Mask)* make other possible works form in my head, often elliptically, sometimes with reference to my own films – made and unmade. After 'the end' there is opportunity to revise your summary, come up with a slightly different story, rearrange possibilities productively, or at least curiously. In the clash of what is and what could have or should have been written, painted or filmed, Elena Ferrante sees pure possibility and fecund source. This certainly gives me hope. She writes:

> *Between the book that is published and the book that readers buy there is always a third book, a book where beside the written sentences are those which we imagined writing, beside the sentences that readers read are the sentences they have imagined reading. This third book, elusive, changing, is nevertheless a real book. I didn't actually write it, my readers haven't actually read it, but it's there. It's the book that is created in the relationship between life, writing and reading.*[69]

As I transcribed this quotation I kept thinking of how I still can't understand what the monkey in *Untitled (Human Mask)* wants. How strange the film still feels, and how it has taken me in so many different directions, has burrowed and entangled itself permanently inside my own reflections and ideas. The film in this regard is preternatural, uncanny, disturbing. Thinking of it here in my final sentence is making me shudder...

> *The darkness grew apace; a cold wind began to blow in freshening gusts from the east, and the showering white flakes in the air increased in number. From the edge of the sea came a ripple and whisper. Beyond these lifeless sounds the world was silent. Silent? It would be hard to convey the stillness of it. All the sounds of man, the bleating of sheep, the cries of birds, the hum of insects, the stir that makes the background of our lives – all that was over. [...] I saw the black central shadow of the eclipse sweeping towards me. In another moment the pale stars alone were visible. All else was rayless obscurity. The sky was absolutely black.*
> – H.G. Wells[70]

Stills from Pierre Huyghe, *Untitled (Human Mask)*, 2014, film, colour, sound 19min. Courtesy the artist; Marian Goodman Gallery, New York; Hauser & Wirth, London; Esther Schipper, Berlin; and Anna Lena Films, Paris

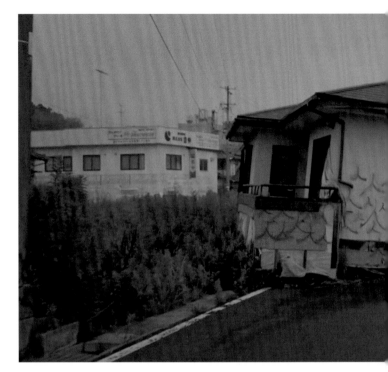

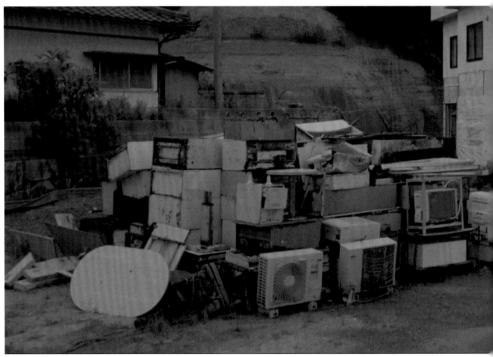

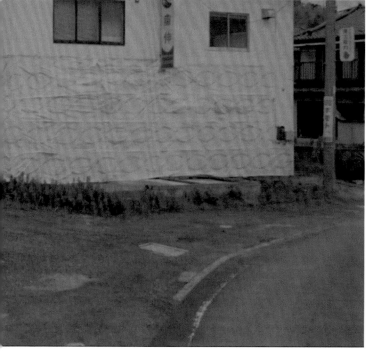

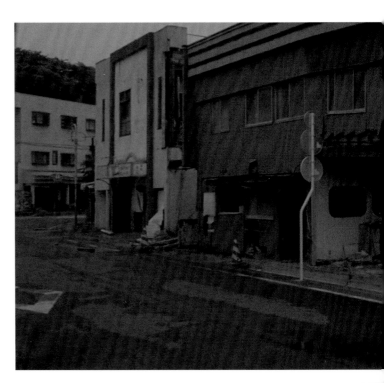

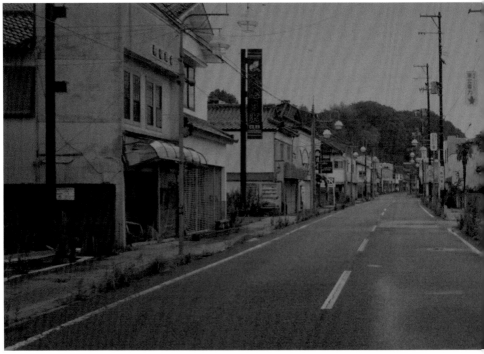

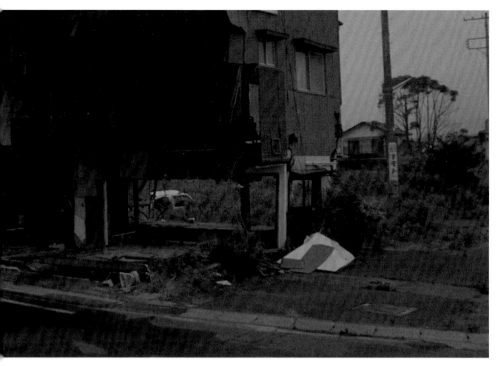

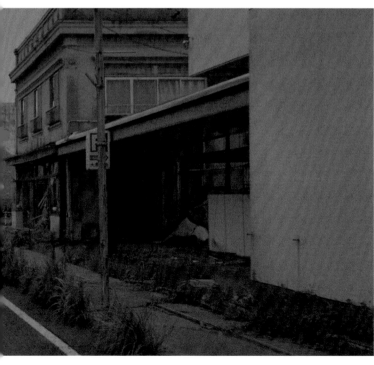

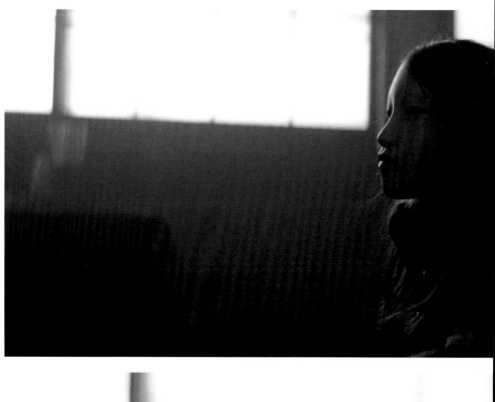

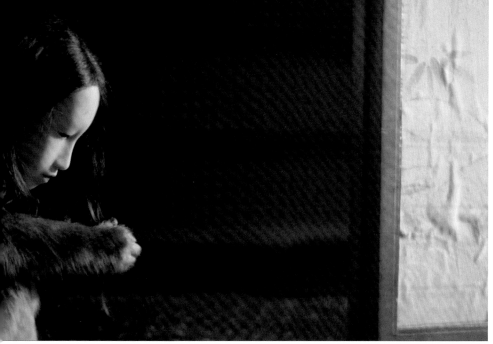

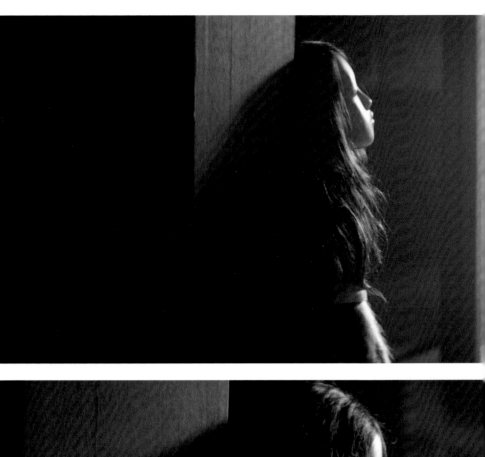
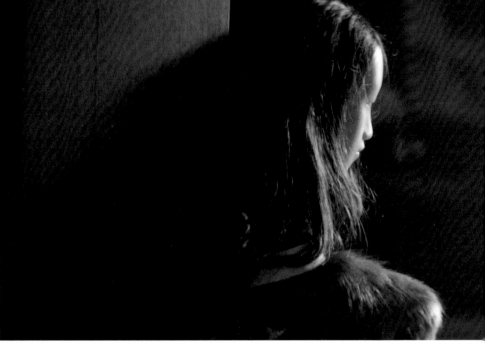

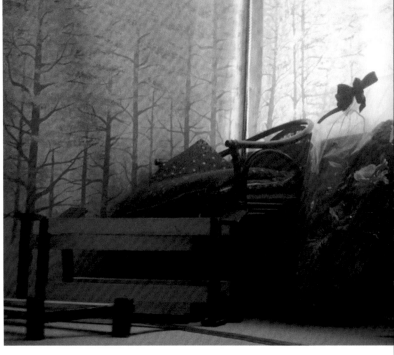

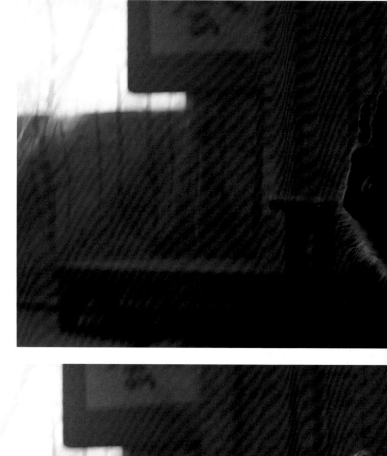

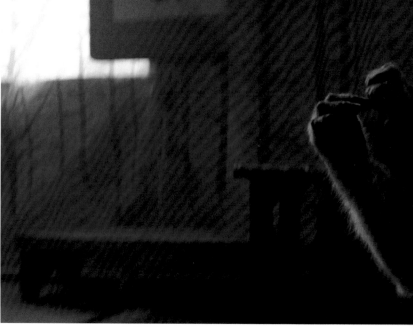

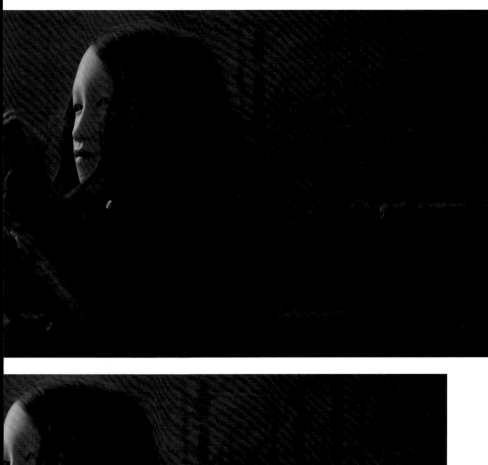

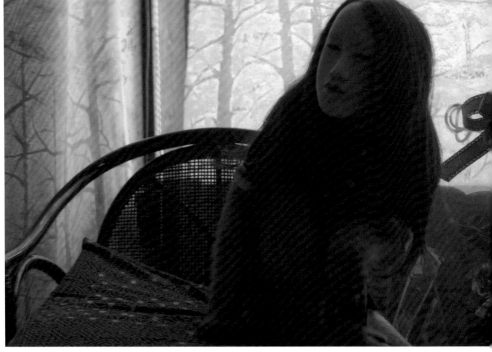

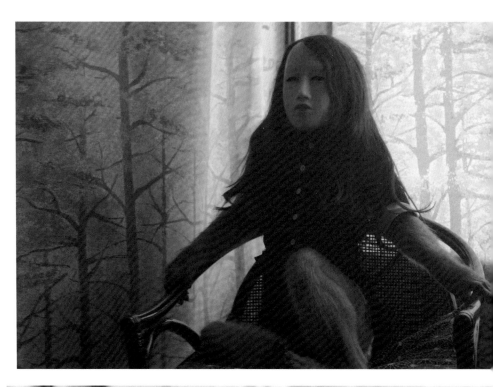

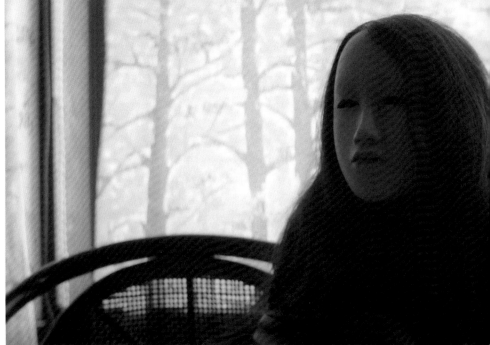

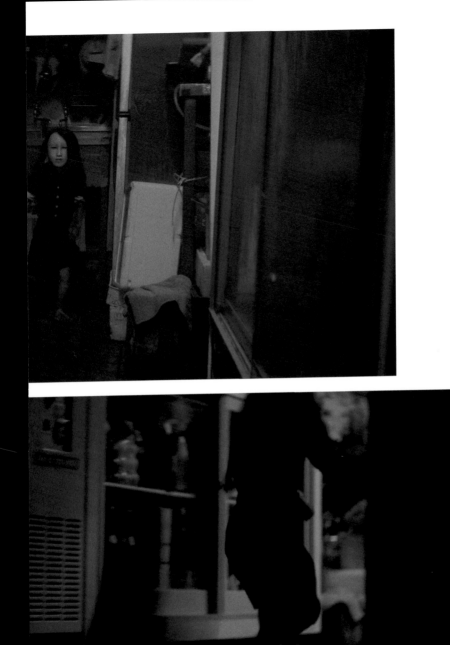

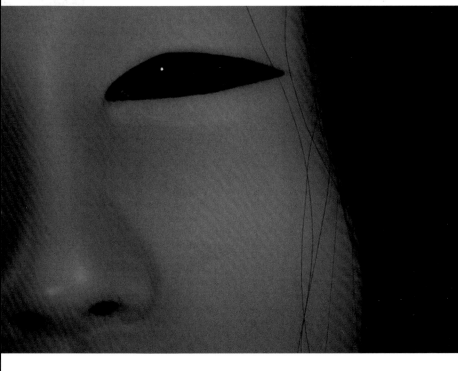

1 Available at https://en.wikipedia.org/wiki/Kayabukiya_Tavern (last accessed on 9 June 2021).

2 'The Cemetery Where Al Jolson is Buried', *The Collected Storied of Amy Hempel*, New York: Scribner, 2007, p.29.

3 Charles Baudelaire, 'The Salon of 1846', *Art in Paris, 1845-1862: Salons and Other Exhibitions* (trans. and ed. Jonathan Mayne), London: Phaidon, 1965, pp.99-100.

4 Ruth Yeazell, *Picture Titles: How and Why Western Paintings Acquired Their Names*, Princeton, NJ: Princeton University Press, 2015.

5 John C. Welchman, *Invisible Colors: A Visual History of Titles*, New Haven and London: Yale University Press, 1997, p.9.

6 Søren Kierkegaard, *Stages on Life's Way* (ed. and trans. Howard and Edna Hong), Princeton, NJ: Princeton University Press, 2013, quoted in Alva Noë, *Infinite Baseball: Notes from a Philosopher at the Ballpark*, Oxford: Oxford University Press, 2019, p.1.

7 Gaston Leroux, *The Phantom of the Opera* (trans. Alexander Teixeira de Mattos), Eternal Sun Books, 2017, p.213.

8 David Lowenthal, *The Past Is a Foreign Country – Revisited*, Cambridge: Cambridge University Press, 2015, p.1.

9 Ann Patchett, 'These Precious Days', *Harper's Magazine*, January 2021.

10 See Charles W. Hedrick, Jr, *History and Silence: Purge and Rehabilitation of Memory in Late Antiquity*, Austin: University of Texas Press, 2000, p.368.

11 Ralph Waldo Emerson, 'Self-Reliance', *Self-Reliance and Other Essays*, Minneola, NY: Dover Thrift Editions, 1993, p.19.

12 Joshua Rothman, 'What If You Could Do It All Over?', *The New Yorker*, 14 December 2020.

13 Jane Mayer, 'The Predator War', *The New Yorker*, 26 October 2009, quoted in Gregoire Chamayou, *A Theory of the Drone* (trans. Janet Lloyd), New York: The New Press, 2014.

14 Joanna Demers, *Drone and Apocalypse*, Winchester: Zero Books, 2015, p.9.

15 Alex Quicho, *Small Gods*, Winchester: Zero Books, 2021, p.3.

16 Bart D. Ehrman, *How Jesus Became God: The Exaltation of a Jewish Preacher from Galilee*, New York: HarperOne, 2014, p.59.

17 D. Lowenthal, *The Past Is a Foreign* Country, *op. cit.*, p.610.

18 See Frank Kermode, *The Sense of an Ending: Studies in the Theory of Fiction*, Oxford: Oxford University Press, 2000.

19 Philip Larkin, 'Aubade', in *Collected Poems*, London: Faber & Faber, 2003, p.240.

20 'The average life span of a species varies according to taxonomic group. It is as long as tens of millions of years for ants and trees, and as short as half a million years for mammals. The average span across all groups combined appears to be (very roughly) a million years. By that time the species may have changed enough to be called a different species, or

else it may have split into two or more species – or vanished entirely to join the more than 99 percent that have come and gone since the origin of life.' Edward O. Wilson, *Half-Earth: Our Planet's Fight for Life*, New York: Liveright, 2016, p.155.

21 P. Larkin, 'Aubade', *op. cit.*

22 June Cummins, 'The Resisting Monkey: "Curious George", Slave Captivity Narratives, and the Postcolonial Condition', *ariel*, vol.28, no.1, January 1997.

23 Henry Louis Gates, Jr, *The Signifying Monkey: A Theory of African-American Literary Criticism*, Oxford: Oxford University Press, 1988.

24 Thorstein Veblen, 'Dress as an Expression of the Pecuniary Culture', in *The Theory of the Leisure Class: An Economic Study of Institutions*, New York: Macmillan Company, 1899, pp.167-87.

25 Joaquim Maria Machado de Assis, *The Posthumous Memoirs of Brás Cubas*, London: Penguin, 2020.

26 Fredric Jameson, *The Benjamin Files*, London and New York: Verso, 2020, p.2.

27 Paul North, *Bizarre-Privileged Items in the Universe: The Logic of Likeness*, New York: Zone Books, 2021, p.20.

28 Henri Bergson, *Laughter: An Essay on the Meaning of Comic* (1900; trans. Cloudesley Brereton and Fred Rothwell), available at http://www.authorama.com/laughter-6.html (last accessed on 27 May 2021).

29 See Adam Kirsch, 'The Symbolic Animal', *The New York Review of Books*, 8 April 2021.

30 See Charles Grivel, 'Production de l'intérêt Romanesque', *Belphégor: Littérature Populaire et Culture Médiatique*, vol.9, no.2, 2010.

31 Frank Kermode, 'Eliot and the Shudder', *London Review of Books*, vol.32, no.9, 13 May 2010.

32 Theodor W. Adorno, *Aesthetic Theory* (1970; trans. Robert Hullot-Kentor), Minneapolis: University of Minnesota Press, 1997, pp.245-46.

33 W.B. Yeats, 'Leda and the Swan', in *The Poems of W.B. Yeats: A New Edition* (ed. Richard J. Finneran), London: Macmillan, 1989, p.182.

34 John Ashbery, 'The Impossible: On Gertrude Stein's Stanzas in Meditation', *Poetry Magazine*, July 1957, pp.250-54.

35 Gabriel Zaid, *So Many Books: Reading and Publishing in an Age of Abundance*, Philadelphia: Paul Dry, 2003, p.22.

36 Wisława Szymborska, 'Brueghel's Two Monkeys', in *Calling Out to Yeti* (1957; trans. Stanisław Barańczak & Clare Cavanagh), New York: Harcourt Brace, 1998, p.15.

37 Desmond Morris, *The Naked Ape: A Zoologist's Study of the Human Animal*, London: Vintage, 2005.

38 W.E.B. Du Bois, *Black Reconstruction in America: An Essay Toward a History of the Part Which Black Folk Played in the Attempt to Reconstruct Democracy in America, 1860-1880* (1935), Cambridge: The Free Press, 1998, p.xxxvi.

39 Hilton Als, 'The Animals and their Keepers: Garry Winogrand and Photography After September 11th', available at http://www.columbia.edu/cu/najp/publications/articles/Als.pdf (last accessed on 1 June 2021).

40 Donna Haraway, *Primate Visions: Gender, Race, and Nature in the World of Modern Science*, London and New York: Verso, 1992, p.11.

41 Mark Rothko and Adolph Gottlieb, letter to the art editor, *The New York Times*, 7 June 1943.

42 Douglas Coupland, *Microserfs*, London: Flamingo, 1996, p.166.

43 Eugene Thacker, *In the Dust of this Planet*, Winchester: Zero Books, 2011, p.8.

44 *The Collected Works of Theodore Parker Sermons Prayers*, vol. 2. London: Trübner, p.48.

45 Martin Luther King, Jr, 'Remaining Awake Through a Great Revolution', speech delivered at the National Cathedral, Washington DC, 31 March 1968.

46 Georges Didi-Huberman, *Confronting Images: Questioning the Ends of a Certain History of Art* (1990; trans. John Goodman), University Park: The Pennsylvania State University Press, 2005, p.21.

47 E.P. Thompson, *The Making of the English Working Class* (1963), London: Penguin, 2013.

48 Jacques Derrida, *The Animal That Therefore I Am* (2002; ed. Marie-Louise Mallet, trans. David Wills) New York: Fordham University Press, 2008, p.3.

49 *Ibid.*, p.4

50 'Masks are very important in the Noh and are typically worn only by the main character. The mask helps to raise the action out of the ordinary, to freeze it in time. For the Noh actor the mask of a particular character has almost a magic power. Before putting it on he will look at it until he feels the emotion absorbed within himself.' Weatherhead East Asian Institute at Columbia University, 'Noh Drama', *Asia for Educators*, available at http://afe.easia.columbia.edu/special/japan_1000ce_noh.htm (last accessed on 1 June 2021).

51 David Krasner, *Resistance, Parody, and Double Consciousness in African American Theatre, 1895-1910,* London: St. Martin's Press, 1997, p.32.

52 Marvin McAllister, 'Whiting Up: Whiteface Minstrels and Stage Europeans', *African American Performance*, Chapel Hill: University of North Carolina Press, 2011, p.47.

53 Ray Bradbury, 'A Sound of Thunder' (1952), *A Sound of Thunder and Other Stories*, New York: William Morrow, 2005, p.203.

54 I write this as someone who regularly makes films less than a few minutes in length and who once entitled a text 'Trying Not to Make Films Too Long'.

55 William Shakespeare, *As You Like It* (1623), act 3, scene 5.

56 J. Ashbery, 'The Impossible', *op. cit.*

57 St. Augustine, *Confessions*, book 11.

58 Michael Wood, 'At the Movies', *London Review of Books*, vol.30, no.19, 9 October 2008. V.F. Perkins also writes beautifully about *Le Masque* in 'Le Plaisir: "The Mask" and "The

Model"', *Film Quarterly*, vol.63, no.1, Autumn 2009, pp.15–22 (my thanks go to Laura Mulvey for alerting me to this text).

59 Charlie McCarthy, the famous ventriloquist dummy from the 1930s through to the 60s, was invented by Edgar Bergen. Charlie's face looks like a mask – which of course it is, in a way.

60 Verlyn Klinkenborg, 'A Noah's Ark of Books', *The New York Review of Books*, 17 December 2020.

61 Alfred Hayes, *In Love* (1954), London: Penguin, 2017, p.5.

62 David Bowie, 'Five Years,' on the album *The Rise and Fall of Ziggy Stardust and the Spiders from Mars* (RCA Records, 1972).

63 Quoted in Galen Strawson, 'Is R2-D2 a Person?', *London Review of Books*, vol.37, no.12, 18 June 2015.

64 I borrow here from the title of Kim Stanley Robinson's 2020 novel.

65 Thomas Hobbes, *Leviathan: The Matter, Forme, & Power of a Common-Wealth Ecclesiastical and Civill*, 1651.

66 Hollis Frampton, 'The Invention Without a Future', *October*, vol.109, Summer 2004, p.67.

67 Wallace Stevens, 'The Necessary Angel: Essays on Reality and the Imagination', quoted in Frank Doggett 'The Poet of Earth: Wallace Stevens', *College English Journal*, vol.22, no.6, March 1961, p.373.

68 Michel Serres, *Biogea* (trans. Randolph Burks), Minneapolis: Univocal Press, 2012, p.26.

69 Elena Ferrante, *Frantumaglia: A Writers' Journey*, New York: Europa Editions, p.300, quoted in Patricia Lockwood, 'I hate Nadia beyond Reason', *London Review of Books*, vol.43, no.4, 18 February 2021.

70 H.G. Wells, 'The Time Machine' (1895), in *The Time Machine and Other Works*, Hertfordshire: Wordsworth Classics, 2017, p.72.

Notes